APOCALYPSE

...and the Magnificent Sevens

APOCALYPSE

...and the Magnificent Sevens

An
Exciting
New Look
at an
Amazing Prophecy

by
BONNIE GAUNT

Adventures Unlimited Press
Kempton, Illinois 60946, U.S.A.

Adventures Unlimited Press
P.O. Box 74
Kempton, IL 60946 U.S.A.
auphq@frontiernet.net
www.adventuresunlimitedpress.com

Manufactured in the United States of America

ISBN 1-931882-03-7

Hebrew Gematria is based on the Masoretic Text.
Greek Gematria is based on the Nestle Text

Contents

Foreword

Many years ago, when I was a little girl, growing up in Florida, I would retreat to my secret hideaway, high in the live oak tree in our front yard. My special place was amply surrounded by a graceful, flowing profusion of Spanish moss. It was a special place. I could not be seen from the ground. Yet, from my perch high above the mundane world, I could see the full panorama of the neighborhood, far over the fields and woods, and into the puffy white clouds that continually created images against the deep blue of the sky. And I would dream!

I dreamed of the day when I could write; when I could put on paper the things that filled my mind and my imagination. I wanted to be a writer.

My writing pad would accompany the climb to my hiding place, and I would write stories, pulled from my imagination of what life should be. The world that I imagined was a beautiful and exciting place, filled with love and friendship and the beauty of all the lovely unknown-to-me far away places.

In my hiding place I lived a very special relationship with God. I could talk to Him, and know that He was my friend.

But reality always won in the end, and I would come down from my "flying carpet" to the very limited experience of growing up in poverty.

As I matured, my relationship with God deepened, and at the age of fifteen I fully dedicated my life to Him. It was an offering of love.

But I'm a late bloomer. It was not until mid-life, after my family had grown, that I began the serious work of writing my first book. The publication of that book changed my life. I began receiving letters and phone calls from people in all parts of the world, thanking me for the concepts that it contained. One very special letter came from a little Chinese boy in Malaysia. He wrote in perfect English: "I have been curious about Christianity, and now, after reading your book, I have decided to become a Christian."

That was over twenty years ago. Now we have come to the year 2002 and I offer you my eleventh book. It has been a glorious ride, and along the way I have learned many beautiful things about our great magnificent God and His plan for the salvation and restoration of His human family.

In this book, I ask you to share with me the joy of the book of Revelation. I know – most people don't think of that book as a "joy." But let me suggest the opening of some doors that will make the complicated simple, the feared an anticipation, and the outcome a magnificent joy.

Bonnie Gaunt
Jackson, Michigan, February 2002

Hebrew and Greek Gematria

Aleph	א	1	Alpha	α	1	
Beth	ב	2	Beta	β	2	
Gimel	ג	3	Gamma	γ	3	
Daleth	ד	4	Delta	δ	4	
He	ה	5	Epsilon	ε	5	
Vav	ו	6	Zeta	ζ	7	
Zayin	ז	7	Eta	η	8	
Cheth	ך ח	8	Theta	θ	9	
Teth	ט	9	Iota	ι	10	
Yod	י	10	Kappa	κ	20	
Kaph	כ	20	Lambda	λ	30	
Lamed	ל	30	Mu	μ	40	
Mem	ם מ	40	Nu	ν	50	
Nun	ן נ	50	Xi	ξ	60	
Camek	ס	60	Omicron	o	70	
Ayin	ע	70	Pi	π	80	
Pe	ף פ	80	Rho	ρ	100	
Tsadey	ץ צ	90	Sigma	$\sigma\varsigma$	200	
Qoph	ק	100	Tau	τ	300	
Resh	ר	200	Upsilon	υ	400	
Shin	ש	300	Phi	ϕ	500	
Tav	ת	400	Chi	χ	600	
			Psi	ψ	700	
			Omega	ω	800	

1

Apocalypse

Apocalypse has come into the vocabulary of this generation as meaning world-wide cataclysmic events and something to be greatly feared. The very mention of the word conjures up mental images comparable to the collapse of the Twin Towers of the World Trade Center. However, the word itself is quite benign.

Apocalypse is a Greek word meaning "revelation" or "to reveal."

Our first response, when we learn the true meaning of the word, is to protest that the last book of the Bible should be called, of all things, *"Apocalypse."* We could surely have thought of a more appropriate Greek word with which to describe it. Perhaps we should have called it *"Mysterion,"* Μυστηριον, from which we obtain our English word "mystery." After all, it is the most un-understood book of the entire Bible (my apologies to Ezekiel). This book of symbolic pictures and scenarios appears to be anything but a revelation.

The book begins:

> *"The Revelation of Jesus Christ, which God*
> *gave unto him, to shew unto his servants*

things which must shortly come to pass; and
he sent and signified (sign-ified) *it by his*
angel unto his servant John: who bare record
of the word of God, and of the testimony of
Jesus Christ, and of all things that he saw.
Blessed is he that readeth..."

I'm quoting from an old King James Version that I obtained when I was a teenager, and as I opened to these verses to copy them, I could not help but smile at a penciled-in note I probably wrote 55 years ago. Under *"Blessed is he that readeth"* I found scribbled, "This book was written to be a blessing – not written to argue about." Hmmm, the innocence of youth!

As I look back over those many years I can recall being audience to many arguments over the book of Revelation. Surely its *mysterion* has caused many and varied interpretations.

However, briefly laying aside its *mysterion* (mystery), let's look for a moment at its *apocalypse* (revelation). Part of this lies in its magnificent display of the number seven.

The word "seven" is used in Revelation 7 x 7 (49) times – 44 times it is cardinal (seven), and 5 times it is ordinal (seventh).

This magnificent number is used for the grouping of things which John saw in the vision.

In chapter one we find seven churches and seven

angels. In chapter four we find seven lamps of fire burning before the throne, and seven spirits of God. In chapter five we find a scroll sealed with seven seals, and a Lamb with seven horns and seven eyes, and seven more spirits of God; and in chapter five we see seven things that the Lamb received, *i.e.*, power, riches, wisdom, strength, honour, glory and blessing. In chapter six the Lamb opens the seven seals, one at a time. In chapter 8 He removes the seventh seal and then John saw seven more angels with seven trumpets. In chapter ten we find the mysterious seven thunders, which John was not allowed to describe. In chapter twelve we find the first mention of the great red dragon who had seven heads and seven crowns on his heads. In chapter thirteen a beast rises out of the sea having seven heads. In chapter fifteen we see seven more angels carrying seven vials (bowls) which contain seven plagues, which are the *"wrath of God."* In chapter seventeen we see a woman sitting on a beast which had seven heads (probably the same beast as in chapter thirteen). These seven heads are described as seven mountains (kingdoms) which have seven kings. In chapter twenty-one we again see one of the same seven angels who had the bowls which had contained the seven plagues (but the bowls are now empty); and thereafter in the book of Revelation we find no more sevens. Everything from that point onward is counted in groups of twelve.

Let's count the sevens, being careful not to count the

same group twice.

seven churches
seven golden candlesticks
seven stars
seven angels
seven lamps of fire
seven spirits
seven seals
seven horns
seven eyes
seven more spirits
seven things Lamb receives
seven more angels
seven trumpets
seven thunders
seven heads
seven crowns
seven more heads
seven more angels
seven bowls
seven plagues
seven mountains
seven kings

There are 22 groups of sevens – the same number as the letters of the Hebrew alphabet. This is three full octaves.

1 2 3 4 5 6 7 | 8/1 | 2 3 4 5 6 7 | 8/1 | 2 3 4 5 6 7 | 8 |

א ב ג ד ה ה ו ז ח ט י כ ל מ נ ס ע פ צ ק ר ש ת

It should be noted that $\frac{22}{7}$ was the ancient number for *pi* (π), which is used to determine the size of a circle. This figure for *pi* is used in all ancient sacred geometry. Authenticity for its use is here demonstrated with the octaves of Revelation.

I suggest that the *"seven thunders"* which John was not allowed to record, become the final note of the three octaves. It was the voice of God. We do not know what these seven thunders are, because John was told not to write them down, but from the symbolic language used elsewhere in the book of Revelation, it would suggest seven proclamations from the Almighty. And the time frame appears to be when Jesus has pulled all of the seals off the scroll and He stands with the open scroll in His hand, proclaiming that man's right to rule has come to an end. Man's "time" is up. (Revelation 10:6)

The *Apocalypse* (Revelation) and the sevens are intricately interwoven; and there is compelling evidence that the sevens are part of a larger plan – a plan formulated from the beginning, by the unfathomable mind of the Creator.

In the search for clues, let's take a closer look at the number seven.

Demonstration of $\dfrac{22}{7}$ in Sacred Geometry

The earth and its moon, as a unit, orbits the sun. That unit bears the number of the Lord Jesus Christ when $\dfrac{22}{7}$ is used for pi.

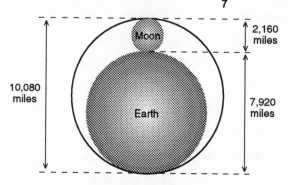

10,080 x $\dfrac{22}{7}$ = 31,680 miles

Circumference of earth-moon unit = 31,680 miles

Number value of "Lord Jesus Christ" = 3168

The 22 letters of the Hebrew alphabet complete three groups of 7, plus the final note of conclusion.

2

Jesus and the Magnificent Sevens

The search for the magnificent sevens is sort of like playing hide-and-seek with a little boy who holds up a sign saying "Here I am."

However, it is first necessary to look at a few basics, which will make the evidence more obvious and meaningful. It is fundamental to realize that the original texts of the Bible used alphabets whose function was as "dual character" systems. That is, each letter of the alphabet had two functions – the meaning of sound (phonetics) and the meaning of number (quantity). Separate symbols for numbers were not in use. Letters of the alphabet were used as numbers. To the Greeks, this system was called Gematria. The Hebrew name for it has long been lost to history. In today's language, it has been called a number code. We usually think of a code as something very secret and difficult to decipher; however, the Bible's number code is neither secret nor difficult. It is there for all to see, and it only requires simple addition. It also requires the use of the Hebrew text for the Old Testament, and a Greek text for the New Testament. These can be obtained from any Bible book store.

With Greek text in hand, let's go to the book of Revelation and find the word "seven." It is not hard to find. There

are 49 of them. The word in Greek is επτα *(hepta)*, from which we derive the word heptad, meaning seven. By adding the number values of its Greek letters we obtain the number 386.

Seven

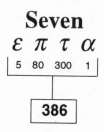

It is, in fact, a very special number. The name Jesus, when spelled in Hebrew has a number value of 386.

Jesus
(Yeshua)

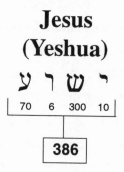

The above demonstration of Gematria speaks loudly that Jesus and the number seven are related in meaning and purpose.

The best way of confirming the meaning of a number is to find how it is used in the text. Below is a demonstration of how the number 386 is used in both the Greek and the Hebrew texts. Note the connection between these words and the purpose and work of Jesus Christ.

386 = Save, הרשעה (II Sam. 14:4)

386 = He will save, רישע

386 = He shall save, ירשע (Job 22:29)

386 = His salvation, ישעו (Psa. 85:10; Psa 24:5)

386 = To buy, αγορασια (Rev. 3:18) (Jesus purchased us with His own blood.)

386 = Made peace, רישלם (Job 9:4)

386 = My peace, שלרמי (Isa. 54:10; Jer. 22:7)

386 = Peace offering, שלמיו

386 = Bruised (crushed), רצרץ (Isa. 42:5; Hosea 5:11)

386 = Shall live, ישכרך (Isa. 34:17)

386 = Shall rule, ימשרל (Isa. 3:4; Prov. 22:7)

386 = Powerful, נמרצו (Job 6:25)

386 = Desire, רצונם (II Chron. 15:15) (Jesus is said to be the *"Desire of all nations"* in Haggai 2:7, but a different Hebrew word is used.)

There are more. This is just a sampling; but the meaning of the number 386 becomes obvious – it has to do with Jesus and salvation. But what has this to do with the number

seven? Why does the word "seven" bear the Gematria of 386?

The Hebrew word for "seven" is *sheva*, or *sheba*. This is also the word used everywhere in the Old Testament for "swear," or "to bind with an oath." The man binding himself was said to "seven" himself. There is obviously a play on words here, but this means of communication is common in the Hebrew language. This play on words has the obvious intention of identifying the significance of "seven" with the idea of an oath-bound covenant. An example of this can be found in Genesis 21.

> *"And it came to pass at that time, that Abimelech ... spake unto Abraham saying ... swear* (seven thyself) *unto me here by God that thou wilt not deal falsely with me ... And Abraham said I will swear* (seven myself). *And Abraham reproved Abimelech because of a well of water which Abimelech's servants had violently taken away ... And Abraham took sheep and oxen and gave them to Abimelech, and both of them made* (cut) *a covenant. And Abraham set seven ewe lambs of the flock by themselves. And Abimelech said unto Abraham, What means these seven ewe lambs which thou hast set by themselves?*

And he said, For these seven ewe lambs shalt thou take of my hand that they may be a witness unto me that I have digged this well. Wherefore he called that place Beer-sheba (well of sevening), *because there they both sware* (sevened themselves).*"*

Immediately after this God called Abraham to take his only son, Isaac, to Mount Moriah and there offer him to the Lord in sacrifice. Because of Abraham's faithfulness in this, the angel of the Lord said to him:

"By myself, saith Jehovah, I have sworn (sevened myself – or bound myself with an oath) *... and because thou hast done this thing and not withheld thine only son, that in blessing I will bless thee ... so Abraham returned ... and went together to Beer-sheba* (well of sevening); *and Abraham dwelt at Beer-sheba."* (Genesis 22)

From its use in scripture, we observe that the number seven is the number of oath-bound covenant relationship. This can be observed also in the covenant that God made with Abraham, giving him all the land from *"the river of Egypt unto the great river, the river Euphrates."*

Abraham asked God, *"Whereby shall I know that I shall inherit it?"*

God answered him with explicit instructions:

"Take unto me an heifer of three years old, and a she goat of three years old, and a ram of three years old, and a turtledove, and a pigeon."

Abraham divided the heifer, the she goat, and the ram, each in half, making six pieces. But the two birds were left whole. Abraham knew that seven was the symbol of an oath-bound covenant, therefore I suggest that he divided the three animals and placed the pieces opposite each other in the manner shown in the diagram below.

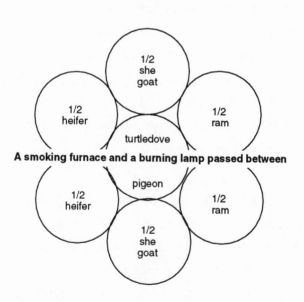

This is the pattern of seven that was used in ancient times to depict a week – six days surrounding the sabbath.

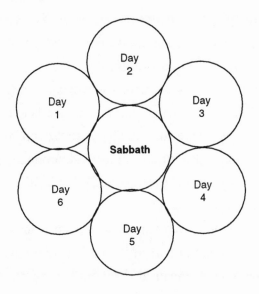

This pattern of six surrounding a Sabbath can apply to a week of days, such as the weekly Sabbath; a week of weeks, such as the counting from Passover to Pentecost; a week of years bringing a Sabbath Year; or even a week of Sabbath Years, bringing a Jubilee.

There was another counting of "seven" that is called *"seven times."* It is also used prophetically, thus is counted by prophetic time, which uses 360 days per year. By this type of counting, the *"seven times"* would be 2,520 years (7 x 360 - 2,520).

This number – 2,520 – appears to be relevant to the sealing of the oath-bound covenant that God made with Abraham that night. He caused a smoking furnace and a burning lamp to pass between the pieces. The Gematria of *"smoking furnace,"* when multiplied, produces the number 2,520 (dropping the extra zeros).

Aside from its awesome chronological significance, the number 2,520 is the lowest number which is evenly divisible by each of the nine digits. The word "seven" in Hebrew, שבוע, when its Gematria is multiplied, produces 2,520. Or the term "seven years" in Hebrew, שבע שנים, when multiplied also produces 2,520.

This prophetic number, used in both Daniel and Revelation, is an integral part of the oath-bound covenant that God made with Abraham that night. This same number is used in Leviticus 26 where God explained to Moses the "seven times" of punishment that would come upon Israel if they disobeyed their Law covenant.

The "burning lamp" that also passed between the pieces of the animals that night has a multiplied Gematria of 288 (dropping the zeros). It apparently relates to and is prophetic of the shedding of the blood of Jesus. When Isaiah prophesied of the event of Jesus on the cross, he said, *"Yet it pleased the Lord to bruise him; he hath put him to grief."* Adding the Gematria of this statement produces 288.

Another, and subsequent event in the life of Abraham

was the "sevening" of God on Mount Moriah. Abraham had followed God's instructions completely, and offered his son, Isaac, on the altar of sacrifice. But God did not allow Abraham to take Isaac's life, but provided a ram as a substitute. Both Isaac and the ram pictured (typed) Jesus, offering Himself as a ransom price for Adam.

Upon the successful enactment of the type, an angel – a spokesman for God – proclaimed to Abraham: *"By myself have I sworn* (sevened myself), *saith the Lord, for because thou hast done this thing, and hast not withheld thy son, thine only son; that in blessing I will bless thee, and in multiplying I will multiply thy seed as the stars of the heaven, and as the sand which is upon the sea shore; and thy seed shall possess the gate of his enemies; and in thy seed shall all the nations* (peoples) *of the earth be blessed; because thou hast obeyed my voice."*

God "swore" by Himself. He "sevened" Himself. The Hebrew word for "swear" is the same word as "seven" – שבעת.

When God made the oath-bound covenant with Abraham, the animals used to bind the covenant were laid in a group of seven. But now, at the sacrifice of Isaac, He swore – sevened – the binding promise to bless *all* mankind. The "seven" that was required to bind the oath was now Jesus, who was foreshadowed by Isaac and the ram. Jesus is the "seven." We saw evidence of this in the Gematria.

Seven

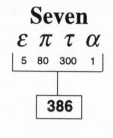

Jesus (Yeshua)

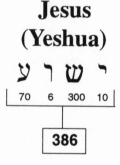

These three digits, 3, 8 and 6, are full of meaning. Briefly, the number 6 represents man; the number 3 represents resurrection; and the number 8 represents a New Beginning through Jesus Christ. The three numerals in combination tell the whole plan of God for the salvation and restoration of man. How appropriate that these three numerals should define His name!

Add the three numerals and the total is 17. Multiply the three numerals and the product is 144. Look at the magnificent significance of these two numbers, and how they relate to Jesus.

$$3 + 8 + 6 = 17$$
$$3 \times 8 \times 6 = 144$$

The number 17 is the seventh prime, or indivisible number. In the scriptures it bears the idea of victory – victory in and through Jesus Christ. This translates to victory over death. The Apostle Paul, when describing the resurrection, exclaimed:

> *"O death where is thy sting? O grave where is thy victory? Thanks be unto God which giveth us the victory through our Lord Jesus Christ."* (I Corinthians 15:55-57)

In these words of Paul we find a beautiful relationship of "victory" to the "all" of mankind for which Jesus died. It speaks of salvation and resurrection. Here is the Gematria of Paul's words, directly from the Greek text.

2376 = The One giving us the victory
 τω διδοντι ημιν το νικος

This beautiful number – 2376 – is 3 x 792. The number 3 represents resurrection and the number 792 is the Gematria for salvation. Thus salvation times resurrection gives "victory" to all.

The Hebrew word "salvation" has a number value of 792. The Hebrew spelling of "Lord Jesus Christ" also has a number value of 792. Earth, the *place* of salvation, has a mean diameter of 7,920 miles.

The connection between man's home – the earth – and Jesus Christ, and man's victory over death (the resurrection) is not an idle coincidence. It is a beautiful and marvelous reality, planned from the beginning by a Master Mathematician! Observe it in its beauty and simplicity:

The One giving us the victory

$$\tau \omega \quad \delta \iota \delta o \nu \tau \iota \quad \eta \mu \iota \nu \quad \tau o \quad \nu \iota \kappa o \varsigma$$

| 300 | 800 | 4 | 10 | 4 | 70 | 50 | 300 | 10 | 8 | 40 | 10 | 50 | 300 | 70 | 50 | 10 | 20 | 70 | 200 |

2376

Salvation

ישערות

| 400 | 6 | 70 | 6 | 300 | 10 |

792

Lord Jesus Christ

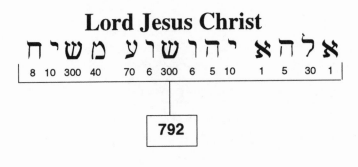

3 x 792 = 2376

The number 17 as it relates to Jesus and victory over death can be seen in the event where Jesus had the disciples pull the net to shore and it contained 153 fish. These 153 fish which had been drawn to shore specifically represent those who receive the "first" resurrection spoken of in Revelation 20:6.

Each of the circles in the following diagram represents one fish. Beginning with 17 circles (fish) and building upward as the circles fit into each other, we can total 153 fish. Notice how the circles fit into groups of six surrounding the Sabbath.

The victory of those who receive the "first resurrection" is based in the number 17.

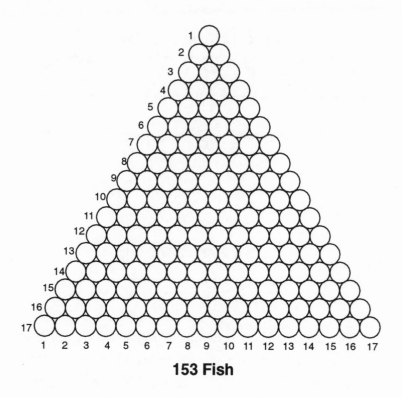

153 Fish

Let's observe some of the uses of the number 17 in relation to Jesus Christ – the means of salvation.

17 = Fish, דגי

17 = Sacrifice, זבח

1700 = Redeem, λυτροω

1700 = My blood of the New Covenant (Mark 14:24)
το αιμα μου της διαθηκης

170 = To rescue (to recover or deliver), נצל

It has been observed that the number 17 is the seventh prime. A prime number is indivisible. Here are the first seven primes. (The number 1 is always excluded because in ancient times it was not considered to be a number. It represented unity.)

$$2 \quad 3 \quad 5 \quad 7 \quad 11 \quad 13 \quad 17$$

Add the digits in these seven primes and we obtain the number 31. Multiply the digits and we obtain 441 (the mirror opposite of 144).

$$2 + 3 + 5 + 7 + 1 + 1 + 1 + 3 + 1 + 7 = 31$$
$$2 \times 3 \times 5 \times 7 \times 1 \times 1 \times 1 \times 3 \times 1 \times 7 = 441$$

Note the use of these two numbers in the Gematria of the scriptures:

31 = God, אל

310 = Lion, כפיר (Jesus was the Lion of the tribe of Judah)

310 = Brightness (glory), יקר

310 = Triumph (glory), שבח

310 = Thunder, רעם

310 = Friend, מרע

441 = Truth, אמת (This word *emet,* (truth) is an acrostic that stands for "God the Eternal King, in the infinite past, present and future.")

How interesting that 441 should mean "God the Eternal King, in the infinite past present and future." Its mirror opposite, 144, carries the same meaning.

The Hebrew word *kedem,* קֶדֶם, has the meaning of "everlasting" or that which has no beginning nor ending – eternity or eternal. Its Hebrew letter/numbers add to 144. The meaning of *kedem* is best represented by a circle, which has no beginning nor ending point. The word "circle" in Hebrew is חוג, which multiplies to 144 and adds to 17. The inter-relationship of the numbers 17, 144 and 441 is magnificent! And they are all embodied in the number 386 (Jesus and seven).

$$3 + 8 + 6 = 17$$
$$3 \times 8 \times 6 = 144$$

The use of these numbers in relation to Jesus can be found in His full title – Lord Jesus Christ.

Lord Jesus Christ

$$K \upsilon \rho \iota o \varsigma \quad I \eta \sigma o \upsilon \varsigma \quad X \rho \iota \sigma \tau o \varsigma$$

| 20 400 100 10 70 200 | 10 8 200 70 400 200 | 600 100 10 200 300 70 200 |

3168

$$3 + 1 + 6 + 8 = 18$$
$$3 \times 1 \times 6 \times 8 = 144$$

Notice the addition of the digits is now 18 instead of 17. The number 17 represented victory – His victory over death, which promises victory over death for all of Adam's descendants. But now the number is changed to 18. Because of His victory over death, He now provides a New Beginning for all mankind. The number 8 throughout the Bible carries the meaning of New Beginning. The number 1 is Beginning, and the number 8 is New Beginning. It is the complete octave – the full seven notes, followed by the beginning note again, but now at a higher pitch. The 1 becomes the 8.

In Revelation 1:17-18 Jesus identifies Himself as *"I am the living one,"* εγω ειμι ο ζων, which adds to 1800. The whole text reads:

> *"...I am the first and the last: I am he that liveth, and was dead; and, behold, I am alive forevermore, Amen."*

Now is a good place to introduce the number 9. Its meaning is nearly identical to number 7 – perfection, completeness – but with the added concept of fullness, fulfillment, and finality (conclusion). When Jesus used the word *"Amen"* here, He was saying 99, for the Greek word *Αμην* adds to 99.

The number 18 carries the thought of "life" – a Beginning and a New Beginning. Thus the Gematria for the word "life," חי in Hebrew is 18. Sometimes it is written as "He

who lives," חי, which is still 18. Now look carefully and notice the interplay of 1, 8, and 9.

$$99 = \text{I live, אנכי חי (Deut. 32:40)}$$

$$
\begin{array}{rl}
\text{I} & = \textbf{81 (9 x 9)} \\
\textbf{live} & = \textbf{18 (2 x 9)} \\
\hline
& \textbf{99}
\end{array}
$$

Before the beginning of creation God existed. The Hebrew words in Genesis 1:1 *"In the beginning God"* add to 999. It tells us of His fullness and completeness even before creation began. He created man and placed him in a perfect garden. *"The garden of the Lord,"* כגן יהוה adds to 99 (Genesis 13:10). But man fell from the perfection in which he was created, and so Jesus came to redeem him. Jesus enters this world of sin in a place called Bethlehem, βηθλεεμ, which adds to 99. He chooses a Bride, who is represented by the number 144. Revelation 14:4 says *"These were redeemed from among men, being the firstfruits unto God and to the Lamb."* Their identification number – 144 – is ρμδ χειλαδες (144 thousands) which has a Gematria value of 999. And finally the story reaches its fullness with:

"Let him that heareth say Come. And let him that is athirst come. And whosoever will, let him take of the water of life freely." This is followed by a final "Amen," Αμην, 99.

3

The Right of Rulership

We've seen the beauty of the number 17 in relation to Jesus Christ. It is a prime – it is indivisible. Jesus comes as earth's ruler, its King. This is His by right of purchase.

In the Garden of Eden, before Adam sinned, he was given "dominion." When Jesus shed His blood to purchase Adam, He also purchased all that Adam possessed, including the right of "dominion." The Gematria for this is most revealing. (Genesis 1:26)

688 = "Let us make man in our image, after our likeness."
1440 = "Let us make man in our image, after our likeness and let him have dominion."

We saw in the previous chapter that the name Yeshua (Jesus) adds to 386. The multiplication of these digits is 144 (3 x 8 x 6 = 144). The name Jesus, in the New Testament is spelled two ways: *Ιησους* (888) and *Ιησου* (688). In the book of Revelation it is always *Ιησου,* 688.

Man, made in God's image, would logically bear the number 688 – a perfect human being. Jesus came as the exact equivalent (or substitute) of Adam, thus His number, relating to His humanity, is 688. Man, in this perfect condi-

tion was given dominion, as is shown by 1440. Man lost his perfection and thereby forfeited his right to dominion. Jesus came as a perfect man, the exact equivalent of Adam (688) and purchased all that Adam lost, including the right of dominion (1440).

386 = Yeshua (Jesus)
3168 = Lord Jesus Christ

3 x 8 x 6 = 144
3 x 1 x 6 x 8 = 144

In the meantime – the interim between these two events – God set up a typical kingdom under the rulership of David. David, ruling over the kingdom of Israel, represented Jesus, ruling over all mankind. The prophecies are full of this analogy. Fifty days after Jesus' death and resurrection, Peter stood up on the day of Pentecost and made a most revealing statement regarding the right of dominion that Jesus purchased, and its relationship to the rulership of David. He said, in part:

> *"Men and brethren, let me freely speak unto you of the patriarch David, that he is both dead and buried ... therefore being a prophet,*

and knowing that God had sworn (sevened) *with an oath to him, that of the fruit of his loins ... he would raise up Christ to sit on his throne ... This Jesus hath God raised up, whereof we are all witnesses. Therefore, being by the right hand of God exalted, and having received of the Father the promise of the Holy Spirit, he hath shed forth this* (the manifestation of the Holy Spirit) *which ye now see and hear. For David is not ascended into the heavens: but he saith unto himself, The Lord said unto my Lord, sit thou on my right hand until I make thy enemies thy footstool. "* (Acts 2:29-35)

It is not a random coincidence that Peter's quotation from David bears a Gematria of 14400.

14400 = The Lord said unto my Lord, sit thou on my right
hand until I make thine enemies thy footstool.
ειπεν κυριος τω κυριω μου καθου εκ δεξιων μου εως αν θω τους εχθρους σου υποποδιον των ποδων σου

Peter's quotation from King David reveals the transfer of the right of rulership from Adam to Jesus, by the use of the number 144.

This transfer of the right of rulership is shown in symbol in the book of Revelation. It is a scroll that is sealed with seven seals.

The sealing of the scroll is because of Adam's transgression of Divine Law. And not until all seven seals have been removed can the scroll be opened and become a valid, functioning, document. In Revelation 10 John saw a representation of Jesus standing with the open scroll in His hand.

4

The Sevens and Tens of Apocalypse

The sevens and tens of the Apocalypse tell a sad story: they tell the story of man's rulership of the earth – a right that was given to Adam in the Garden of Eden, but which has been misused and abused beyond all attempts at description.

In the twelfth chapter of Revelation we meet a *"great red dragon,"* who has seven heads and ten horns and wearing seven crowns upon his heads. A dragon is a mythical creature, but this dragon is no myth. He is the power behind man's attempts at rulership.

John recorded that Jesus called Satan the *"prince of this world."* Yet we find in Revelation 1:5 the same John calls Jesus *"the Prince of the kings of the earth."* Which is it? Who is the power behind the kings of the earth? The answer, of course, has to do with time.

Let's look at the sevens and the tens and place them in their proper time frame. Thus far we've seen that seven represents perfection and completion. It represents Jesus. It represents that which binds a covenant. Closely akin to its perfection and completion is the concept of universality. Had Adam remained in complete and total obedience to God, his

divinely authorized rulership would have been world-wide in its totality. The Second Adam, however, does indeed obtain divinely authorized rulership that is world-wide. His rule is prophesied to be *"to the ends of the earth"* – an idiom meaning completely world-wide. It is obtained by a binding covenant, sealed by the shedding of His blood on Calvary.

What about the number ten? Ten basically represents man's responsibility to God as is embodied in the Ten Commandments. But ten also represents man's governments, as differentiated from Divine Government, which is represented by the number twelve.

Man was given the right to rule in the Garden of Eden. Under perfect conditions, had Adam not sinned, man's responsibility to God would have included his rulership under the perfect law of God. However, man fell into sin by disobedience to Divine Law. Because of this, man's earthly governments which are symbolized by the number ten, are prophesied to be overthrown by Divine Government, which is represented by the number twelve.

Man was given the right of dominion in the Garden of Eden. Chronology tells us that man has ruled for 6,000 years. And this is exactly as the number symbolism fortells. Man and the earth are represented by the number six. Man's government is represented by the number ten. Thus 6 x 10 x 10 x 10 = 6,000. It suggests that at the end of 6,000 years *"He whose right it is"* will take His rightful place as *"Prince of*

the kings of the earth."

If this be true, then perhaps the book of Revelation can be put into perspective, and can be found to be a very accurate prophecy of time and events, for in it has been given to us an "anchor" – a date point – back from which we can see history unfold, and forward from which we can have confidence in its complete fulfillment. That "anchor," or date point, is given to us in Revelation 10:1-6.

> *"And I saw another mighty angel* (a representation of Jesus) *coming down from heaven, clothed with a cloud, and a rainbow was upon his head, and his face was as it were the sun, and his feet as pillars of fire. And he had in his hand a little book* (scroll) *open; and he set his right foot upon the sea, and his left foot on the earth. And he cried with a loud voice, as when a lion roareth."*

John saw this manifestation of Jesus in a vision. He saw Jesus standing with an open scroll in His hand. Then this mighty Being spoke to John.

> *"And the angel which I saw stand upon the sea and upon the earth lifted up his hand to heaven and sware* (sevened) *by him that liveth for ever and ever, who created heaven, and the things that therein are, and the earth and*

the things that therein are, and the sea and
the things which are therein, that there should
be time no longer."

Many have puzzled over the statement that there should
be *"time no longer."* Some translators have rendered it, *"no
longer a delay."* However, the Greek word used here in the
text does not mean delay. It is *chronos,* χρονος, which
always means time.

So, let's try to see what John saw. Jesus is standing with
His left foot on the sea and His right foot on the earth and in
one hand He holds the open scroll; then He raises His other
hand and utters an oath, saying "Time's up!" – or "Your
time has ended." What is the open scroll, and whose time is
up? I suggest that the scroll is the divinely authorized right
to rule; and "time is up" for those who had previously held
that divinely authorized rulership. Their allotted 6,000 years
of rulership has expired, and the One whose right it is stands
in possession of it. It pin-points the conclusion of 6,000 years
from its beginning in the Garden of Eden. This statement –
"Your time is up" – is the anchor which brings all the rest of
the book of revelation into a logical time frame.

Where and when did Jesus get the scroll? In an attempt
to answer this, let's first go back to Revelation 1:1. In the
very first verse of the book we find, *"The Revelation of Jesus
Christ, which God gave unto him, to shew unto his servants
things which must shortly come to pass; and he sent and*

signified *it by his angel unto his servant John."* This is an important key to the understanding of the whole book. The word *"signified"* is from the Greek word *semaino,* σημαινω. According to Thayer's Greek Lexicon, this word *semaino* means "to give a sign, to signify, to indicate." This tells us that the things which John saw were not the actual, literal, people and events – they were "signs" indicating people and events. There is a big difference. Many modern authors use the rule of thumb that "if it makes sense literally, then interpret it as literal." However, I feel it is more important to take John's word for it. After all, he was the one who saw the vision and experienced these things; and he said they were *signs.*

In chapter four, John describes a marvelous scene which he saw in vision. It was the Throne Scene. He apparently saw a sign, or representation, of God sitting on His throne, surrounded by other heavenly beings, which he described as "beasts" and "elders." Then, after having described this marvelous scene, he begins chapter five by saying that the One who was seated on the throne had a scroll in His hand.

> *"And I saw in the right hand of him that sat on the throne a scroll (biblion, βιβλιον) written within and on the backside, sealed with seven seals."*

Let's try to picture in our minds exactly what John saw.

He saw One whom he described as God, sitting on a throne, holding in His hand a scroll which was sealed with seven seals. Perhaps the scroll looked something like this.

John did not tell us what the scroll was a sign of – he merely described what he saw. Then he saw an angel who asked the question: *"Who is worthy to open the scroll and to loose the seals thereof?"* The question was answered: *"The Lion of the tribe of Judah, the Root of David, hath prevailed to open the book, and to loose the seven seals thereof."*

Then John saw a Lamb. Now we are so accustomed to thinking of Jesus as a Lamb, that we automatically picture this as Jesus. However, John did not see Jesus – he saw a Lamb. The Lamb was a sign. It pictured Jesus. Then John saw the Lamb take the scroll out of the hand of the One sitting on the throne. This tells us that the scroll is, at this point in the vision, in the hands of Jesus.

But what is the scroll a sign of, and what is meant by transferring it from the hands of God into the hands of Jesus?

By the rest of the testimony regarding the scroll and the opening of it, I suggest that it represents the right of rulership that was originally assigned to Adam in the Garden of Eden.

Man was given dominion in the Garden of Eden. He was given the right of rulership. It did not take man long to defile that right of rulership. As time progressed, and the selfishness of man increased, his rulership of earth became one of oppression, exploitation, slavery, murder, robery, and death. This all came as a result of Adam's sin.

But in God's appointed time, Jesus came to earth as a perfect man – the exact equivalent of perfect Adam – and He offered His perfect life to pay the price for the sin of Adam. By paying the price for Adam's sin, Jesus purchased all that Adam had before he sinned. This means that Jesus purchased the right of rulership that had been given to Adam. I suggest that at the time He purchased it, the scroll was transferred from the hand of God into the hand of the Lamb. However, he could not open it yet, because it was sealed with seven seals.

Revelation 6 begins the opening of the seals. As each seal is pulled off the scroll, events happen. But notice that as each seal is pulled off, the other seals remain. The scroll cannot be opened until all seven seals have been pulled off. So let's try to see what John saw. He saw a scroll with seven seals, with the first seal having been pulled off, leaving it yet sealed with six seals.

As the Lamb pulled off the first seal, John saw: *"A white horse: and he that sat on him had a bow; and a crown was given to him, and he went forth conquering and to conquer."*

There are many and varied interpretations of who is depicted as the crowned rider on the white horse. Whoever it is, he makes his appearance sometime between the time the scroll was handed to Jesus and the time when He opens the scroll. That is a space of nearly 2,000 years. My suggestion is that the crowned rider on the white horse would be the counterfeit of the crowned rider of a white horse in Revelation 19:11-13 – and we know who He is because John plainly tells us. *"He has on his vesture and on his thigh a name written, KING OF KINGS and LORD OF LORDS."* So the crowned rider in Revelation 6 must be a counterfeit of Jesus Christ. A counterfeit who fits the description surely did conquer and rule under the name of the Holy Roman Empire. And his rule has not ended, it is being revived in the form of the European Union.

The crowned rider on the white horse is again described in Revelation 17 as a woman sitting on a scarlet colored beast. This beast has seven heads and ten horns, and is said to go out of existence and then revive. Today it is in the "revival" stage.

Then in Revelation 17:9 we are given a bit of secret insight. John says, *"Here is the mind which hath wisdom."* This kind of language alerts us to the fact of a subtle or

hidden meaning for which we are to be aware. Then, after alerting us, he says, *"The seven heads are seven mountains on which the woman sitteth."* Ordinarily we would think of *"seven mountains"* as seven kingdoms, but having been alerted to a more subtle, hidden meaning, we look further. Where is the famed "city of seven hills?" Of course – all roads lead to Rome, it is literally built on seven hills. Rome was the ruler of all Europe and much of Asia and Africa. It was said to "rule the world." The revival of the Roman beast makes war with the Lamb, because it exists at the time when Jesus stands holding the open scroll, and a transfer of rulership is due. And so, in verse 14 *"These shall make war with the Lamb, and the Lamb shall overcome them."*

Thus, the opening of the first seal begins early in the Christian era, and its crowned rider does not meet his overthrow until after Jesus stands with the open scroll.

This scenario of events was prophesied in Psalm 2.

> *"The kings of the earth set themselves, and the rulers take counsel together, against the Lord, and against his anointed* (Messiah), *saying, Let us break their bands asunder, and cast away their cords from us. He that sitteth in the heavens shall laugh: the Lord shall have them in derision ... Yet have I set* (past tense) *my king upon my holy hill of Zion.* (The right of rulership has been transferred to

Jesus). *I will declare the decree: the Lord hath said unto me, Thou art my Son; this day have I begotten thee. Ask of me and I shall give thee the heathen for thine inheritance, and the uttermost parts of the earth for thy possession. Thou shalt break them with a rod of iron; thou shalt dash them in pieces like a potter's vessel."*

Jesus cannot take His authority as earth's rightful ruler until all seven seals have been removed from the scroll, because until they are all pulled off, the scroll cannot be opened.

Then John watched as the Lamb pulled off the second seal.

As the Lamb pulled off the second seal, John saw: *"Another horse that was red: and power was given him to take peace from the earth, and that they should kill one another: and there was given unto him a great sword."*

It tells of wars, political unrest, and conquest.

But the scroll still had five seals on it, and could not be opened.

Then John watched as the Lamb pulled off the third seal.

He saw a *"black horse; and he that sat on him had a pair of balances in his hand."* Then John heard a voice saying, *"A measure of wheat for a penny, and three measures of barley for a penny; and see thou hurt not the oil and the wine."*

A penny was a day's wages. If all that could be purchased was one "measure" of wheat, then living conditions would be very sparse. The Greek word translated "measure" is *choenix*, χοινιξ, which is, according to Thayer's Greek Lexicon, "as much as would support a man of moderate appetite for one day." Obviously if he had a wife and family they would live far below the poverty level. What John saw was great and widespread famine.

But the scroll still had four seals on it and could not be opened.

Then he saw the Lamb pull off the fourth seal.

What John saw this time was most frightening. He saw *"a pale horse: and his name that sat on him was Death, and Hell* (Hades, the grave) *followed with him. And power was given unto them over a fourth part of the earth, to kill with the sword, and with hunger, and with death and with the beasts of the earth."*

Very sad conditions are depicted here. People were dying from war and dying from hunger; and their quality of life was reduced to the animal level. Have these conditions ever happened? Yes! Unfortunately these conditions spread across Europe and Asia during the reign of the Holy Roman Empire. The conquest and oppression resulted in extreme poverty and famine, which was followed by disease and death. The bubonic plague (a disease of filth, carried by fleas on rats), called the "Black Death" spread across Europe and Asia in the 14th century, killing about one-fourth of the population during a brief four-year period. The disease was so deadly it often killed within twelve hours of its onset. The Black Death brought an end to the feudal structure of medieval society.

But the scroll, the right of rulership, cannot yet be opened because there are still three seals on it.

Then John watched as the Lamb pulled off the fifth seal. The scene that he looked upon was enough to make even angels weep. He saw a terrible persecution and martyrdom of faithful, precious saints.

"I saw under the altar the souls of them that were slain for the word of God, and for the testimony which they held; and they cried with a loud voice; saying, How long, O Lord, holy and true, dost thou not judge and avenge our blood on them that dwell on the earth?"

But the answer came that it was not yet time for their deliverance, because there would be yet more martyrdom to come.

Did such martyrdom ever really happen? Unfortunately the sad story of precious Christian saints being persecuted and brutally killed for their faith can still be found in the annals of the Roman Catholic Church and its Holy Roman Empire. These records show more than 14,000 people whom they put to death for not renouncing their faith in the redemptive blood of Jesus Christ. Some were put on racks and stretched until their limbs tore from their bodies. Others were tied to the stake and burned alive. There are records that tell of them being roasted on a grid-iron. Some were tied to trees and shot by archers.

No wonder they cried out *"How long!"* But the time of suffering for one's faith in Jesus Christ had not ended. Two

more seals must first be pulled off the scroll.

Then John saw the Lamb pull off the sixth seal, and immediately he saw a very frightening scene. He described it as he saw it.

"... there was a great earthquake; the sun became black as sackcloth of hair, and the moon became as blood, and the stars of heaven fell unto the earth, even as a fig tree casteth her untimely figs when she is shaken of a mighty wind. And the heavens departed as a scroll when it is rolled together; and every mountain and island were moved out of their places. And the kings of the earth, and the great men, and the rich men, and the chief captains, and every freeman, hid themselves in the dens and in the rocks of the mountains, and said to the mountains and rocks, Fall on us, and hide us from the face of him that sitteth upon the throne, and from the wrath of the Lamb. For the great day of his wrath is come; and who shall be able to stand."

Wow! John must have been terrified! He did not see the literal events. He saw only their "signs." But the signs are frightening indeed.

Earthquake, in scriptural symbology, represents "revolution" – changes in government and in society that cause great upheaval and human suffering. The revolutions that have taken place since the fall of the great Holy Roman Empire have completely changed the world, and caused world wars, suffering, famine, and death. The communist revolution has been the seed that has grown and spread its roots into nearly every nation and peoples.

The sun became black and the moon turned to blood – symbols of the true light of the gospel of salvation. It was turned to darkness and blood by the godless doctrines of the communist revolution, making a godless state.

Many of us have lived through these societal and governmental revolutions. Society has taken refuge in their governments (mountains), where they can hide (feel safe) from the upheaval of revolution. All the while human morals and decency have experienced decay beyond all recognition.

My generation has lived through some of the things that John saw when the Lamb pulled off the sixth seal. It is not over yet, but it is rushing to its crescendo.

In summary, we have seen that the pulling off of the six seals revealed these six things:

1. **A false Christ (anti-christ system)**
2. **Wars**
3. **Famines**
4. **Death**
5. **Martyrs**
6. **Earthquake**

These six things were prophesied by Jesus and recorded in the 21st chapter of Luke. The disciples had asked Jesus, *"When shall these things be and what sign will there be when these things shall come to pass?"* In His answer, Jesus capsulized the above six events as they would occur from the time He left them until the time of His return. He said:

> *"Take heed that ye be not deceived: for many shall come in my name, saying I am Christ* (1. False Christ) ... *But when ye shall hear of wars and commotions* (2. War) *be not terrified ... Nations shall rise against nation, and kingdom against kingdom. And great earthquakes* (6. Earthquake) *shall be in divers places; famines* (3. Famine) *and pestilence* (4. Death) ... *they shall lay their hands on you and persecute you* (5. Martyrs)."

Jesus was giving them a brief word picture of earth's conditions during the nearly 2,000 years of His absence. And He described the same six things that John saw in the vision:

1. **False Christ**
2. **Wars**
3. **Famines**
4. **Death**
5. **Martyrs**
6. **Earthquake**

This is indeed nearly 2,000 years of history in a nutshell.

Then John watched while the Lamb pulled off the seventh and last seal. The scene changed dramatically!

"And when he had opened the seventh seal, there was silence in heaven about the space of a half an hour. And I saw the seven angels which stood before God; and to them were given seven trumpets ... and there were

voices, and thunderings, and lightnings and
an earthquake. And the seven angels which
had the seven trumpets prepared themselves
to sound."

Then John describes what he saw following each trumpet blast. He did not see actual events. He only saw signs of those events – things that represented those events. Here is what he saw:

8:7	first trumpet	**Third part** of trees and grass burned up.
8:8	second trumpet	**Third part** of sea became blood, sea creatures died, ships destroyed.
8:11	third trumpet	**Third part** of rivers and springs made bitter (embittered, πικραινω, or to visit with bitterness.)
8:12	fourth trumpet	**Third part** of sun, moon and stars darkened
9:1-12	fifth trumpet	Locusts whose king is Abaddon
9:14-21	sixth trumpet	**Third part** of men killed

The blowing of the first six trumpets does not paint a very pleasant picture. But this is what John saw and heard as the Lamb pulled off the seventh seal, allowing the scroll to be opened.

Before looking at the signs, and attempting to find what they represent, let's observe something hidden in the text – its number code. Why did five of these trumpet blasts affect

"the third part" of things? Their Gematria may give us a clue. It appears that the number value of *"the third part"* could be an indication of the time when these six trumpets have been blown, and bring us to the time immediately preceding the sounding of the seventh. The Gematria for the Greek words *"the third part," (the triton, το τριτον),* is 1200. Five of these trumpet blasts violently affected *"the third part"* of things.

$$5 \times 1200 = 6000$$

After the six trumpets had sounded, John saw Jesus standing with the open scroll in his hand.

Then John saw Jesus raise His other hand and swear by heaven that *"Time is up"* for man's rulership of the earth. Man's allotted 6,000 years of dominion comes to an end at this point. One more trumpet blast remains – the last one!

These six trumpet blasts came with the removing of the seventh seal, which enabled the scroll to be opened. May I suggest the possibility that upon the opening of the scroll (right of rulership), the trumpet blasts that John heard and the signs that he saw were a concise summary, or re-cap, of the entire 6,000 years of man's rulership, which reaches its full beastly climax in the end-time. Thus the end-time conditions that it so graphically portrays, are really the culmination of 6,000 years of oppression, exploitation, slavery, murder, robery, and desecration of the planet earth and the society of man on it.

With the first trumpet blast, *"the third part"* of the trees and grass burned up. In the Bible's use of "sign" language, trees represent nations. Jesus used this symbology in His Olivet prophecy (Matthew 24) where He spoke about the fig tree putting forth leaves. He was really speaking about the nation of Israel, but He called it a fig tree. When Luke recorded the same prophecy of Jesus, he wrote *"Behold the fig tree, and all the trees."* Apparently Jesus not only spoke of the nation of Israel as being a tree, but the other nations as well.

The second sign was *"the third part"* of the sea became

blood and the creatures and ships in the sea thus destroyed. In the Bible's use of symbolic language, the sea represents the restless masses of mankind. The symbol draws a vivid picture of the 6,000-year history of man's rulership and the futility of his attempts at providing a workable peaceful society.

With the third trumpet blast *"the third part"* of the rivers and springs were made bitter (cause embitterment). Rivers and springs in the Bible's symbology represent sources and fountains of truth. Surely down through man's 6,000 years he has become embittered against the revelation of divine Truth. Men have *"made lies their refuge"* (Isaiah 28:15). However, the promise was given: *"Judgment will I lay to the line and righteousness to the plummet: and the hail* (divine truth) *shall sweep away the refuge of lies, and the waters shall overflow the hiding places."* (Isaiah 28:17)

The fourth trumpet blast must have been a frightening one for John. He saw *"the third part"* of the sun, moon and stars become darkened. But the symbology is vivid. The sun and moon are our sources of light (Jesus said *"I am the light of the world"*) and the stars are those principal ones who have brought the true gospel light to mankind. But because of the lies that men prefer to believe, the true light has been largely covered over with darkness.

The fifth trumpet blast was a swarm of locusts, which looked more like warriors dressed and armed for battle than

just flying insects. (Literal locusts can be as destructive as an invading army.) And their king was named Abaddon, which means "destruction." This king is called elsewhere *"the prince of this world."* Their king was the one who usurped the rulership from Adam, thenceforth making the rulers of this world his puppets.

Then John heard the blast of the sixth trumpet. And he saw the angel who blew the trumpet come down and loose the four angels who were assigned to slay *"the third part"* of men with fire, smoke and brimstone. The remainder of men who were not killed refused to repent of their *"murders, nor of their sorceries, nor of their fornication, nor of their thefts."* (Revelation 9:21)

And this is the condition of mankind up to and including the time when John saw Jesus standing with the open scroll in His hand.

Then Jesus asked John to do a strange thing. He handed the scroll to John and said, *"Take it, and eat it up; and it shall make thy belly bitter, but it shall be in thy mouth sweet as honey."*

Jesus was asking John to experience the actual effect of man's rulership. Wow! John didn't know what he was getting into! When the right of rulership was given to Adam, it was sweet as honey – it was a wonderful gift given to man, which could have brought much blessing and happiness. But it turned out to be a very bitter pill for mankind. What John

experienced when it reached his stomach was pain and bitterness, and much discomfort. And this is what man's misuse of his rulership has brought to all mankind. Man's rule has been oppression, exploitation, slavery, murder, robery, and death. No wonder John had a tummy ache. In fact, I suspect he experienced downright nausea and vomiting.

As John watched this awesome vision, he saw Jesus do something strange. He saw Jesus lift up one hand toward heaven and He uttered an oath (sevened himself) by *"Him that liveth for ever and ever."* Jesus was about to utter a statement of sworn testimony before God. And what was His statement? He said:

> *"There should be time no longer* (your time
> is up) *but in the days of the voice of the seventh angel* (seventh trumpet blast), *when he
> shall begin to sound, the mystery of God
> should be finished."*

The Greek word used here for *"begin"* to sound literally means "to be on the point of doing something." Some translators have rendered it *"about to sound"* and some have given it *"begins to sound."* I like the literal definition from the Greek because it leaves no doubt. It means that at the same point when the seventh trumpet sounds, the mystery of God would be finished. Bear in mind that the trumpet blast is not a momentary thing, but at the point in time when

the blast begins to sound, the mystery of God will be finished. When is that? And what is the mystery of God?

The Apostle Paul told us about this *"mystery of God"* in his letter to the Colossians. He said:

> *"The mystery which hath been hid from ages and from generations, but now is made manifest to his saints: to whom God would make known what is the riches of the glory of this mystery among the Gentiles; which is Christ in you, the hope of glory."*

He was talking about the call and development of the Bride of Christ. It had not been made known in ages past, but was made known by Jesus at His first coming; and the espousal of the Bride took place on the day of Pentecost, just fifty days after Jesus rose from the grave.

John now tells us that he saw Jesus raise His hand and swear by God that "time is up" and now is the appointed time for the *"mystery of God"* – the Bride – to be complete.

From this, can we decipher the time and find exactly when the Bride will be complete? Not precisely! It puts us in the ball park but does not tell us what base we are on.

Chronology tells us that 6,000 full years from the creation of Adam ended on Rosh Hashanah of 1999. We do not know at what precise point in time the seventh trumpet blast will begin. But obviously the closeness of the event is much cause for rejoicing and joyful anticipation.

The point in time when Jesus stands with the open scroll in His hand and declares to man's governments that "time is up," does, however, provide an anchor – a pivotal point – around which the entire Apocalypse can be placed into its chronological order.

A brief outline of the plan of the Apocalypse can be seen on the following page. Note that some items are introductory, some are concise histories, and some are sort of "flashbacks" which bring the reader up to the point of current action. But there is a general progression of time, leading to earth's great Millennium, which is followed by God's Great Eighth Day – His Grand Jubilee.

Chronological Outline of the Book of Revelation

Chapter 1: Introduction and identification of the One who gave the vision to John.

Reference Point
Jesus stands with
open scroll at end of
man's 6,000 years

Chapters 2 & 3: Church Age. Admonitions and promises apply to whole church during age.

Chapter 4: Throne Scene

Chapters 5 - 11: Opening of seals and blowing of trumpets. Scroll handed to Jesus at time of His resurrection. The entire Church Age has seen the pulling off of the seals. Jesus holds the open scroll just before the blowing of the seventh trumpet.

7th Trumpet Sounds

Chapter 11:1-14: Between the 6th and 7th trumpet. Two witnesses (Law and Prophets) finish their testimony. Mystery of God (Bride) complete just prior to sounding of 7th trumpet.

Chapter 11:15-19: After 7th trumpet begins to sound, Heavenly Temple complete.

Chapter 12: Woman births Man Child. Gap between verses 5 and 6 for Church Age.

Satan cast out of heaven. Antichrist system at fulness.

Chapter 14 Jesus on Mt. Zion with completed church.

Chapter 15: pouring out of bowls of wrath

Chapters 17 & 18: History of the great whore

Great whore cast out

Chapter 19: Marriage of Bride & Lamb

Chapter 20: Satan bound. Millennial Kingdom ⟶

Chapter 21 & 22: Great 8th Day. ⟶

Chapter 22: John's closing conversation with the angel.

5

Marching Around Jericho

"Joshua fit the battle of Jericho ... and the walls came tumblin' down ..." Or so the song goes.

But let's look at the actual scriptural account. This was God's instructions to Joshua:

> *"See, I have given into thine hand Jericho,*
> *and the king thereof, and the mighty men of*
> *valour. And ye shall compass the city, all ye*
> *men of war, and go round about the city once.*
> *Thus shalt thou do six days. And seven priests*
> *shall bear before the ark seven trumpets of*
> *ram's horns: and the seventh day ye shall*
> *compass the city seven times, and the priests*
> *shall blow with the trumpets. And it shall*
> *come to pass, that when they make a long*
> *blast with the ram's horn, and when ye hear*
> *the sound of the trumpet, all the people shall*
> *shout with a great shout; and the wall of the*
> *city shall fall down flat, and the people shall*
> *ascend up every man straight before him."*

The story proceeds with the actual marching around Jericho. For each of six days, armed soldiers marched in

procession with seven priests each blowing trumpets. For each of six days they thus marched around the city once.

> *"And it came to pass on the seventh day, that they rose early about the dawning of the day, and compassed the city after the same manner seven times ... and it came to pass at the seventh time, when the priests blew with the trumpets, Joshua said unto the people, Shout ... so the people shouted when the priests blew with the trumpets ... the wall fell down flat, so that the people went up into the city, every man straight before him, and they took the city."*

For six days they marched in a big circle surrounding the city of Jericho, during each single march around the city the priests blew the trumpet. On the seventh day they rose at daybreak and marched around the city seven times blowing the trumpets. But on the seventh time around, all the people shouted, and the walls of Jericho fell down flat.

There appears to be a similarity between the blowing of trumpets for seven days around Jericho, and the blowing of the seven trumpets of Revelation. Let's explore that possibility. We saw that with the first six trumpets of Revelation *"the third part"* of things was affected five times. The Gematria for *"the third part"* is 1200. Thus 5 x 1200 = 6000

– indicating the 6,000 years of man's allotted rulership. And after the blowing of the sixth trumpet, Jesus stood with the open scroll (the official right of rulership) and declared that "time is up" for man's rulership.

At Jericho the people marched around the city and blew the trumpets once for each of the six days. When we look at the Gematria of the Hebrew text we find something quite remarkable. Below is exactly as it appears in the Masoretic Text.

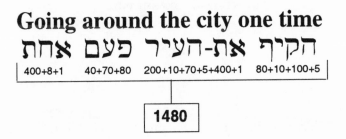

Going around the city one time

הקיף את-העיר פעם אחת

| 400+8+1 | 40+70+80 | 200+10+70+5+400+1 | 80+10+100+5 |

1480

If one day is represented by 1480, then six days would be represented by 6 x 1480.

6 x 1480 = 8880

Joshua is a type, or picture, of Jesus. The name Joshua is the Hebrew pronunciation for the name Jesus. The name means "God saves." The name Jesus in Greek has a number value of 888.

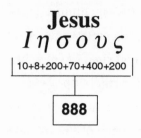

Jesus

$I \eta \sigma o \upsilon \varsigma$

| 10+8+200+70+400+200 |

888

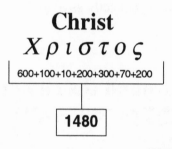

Christ

$X \rho \iota \sigma \tau o \varsigma$

| 600+100+10+200+300+70+200 |

1480

They marched around the city once (1480) for each of six days (6 x 1480 = 8880). It corresponds to the time following the blowing of the sixth trumpet of Revelation where Jesus (888) stands holding the official document giving Him the right of rulership. It is at the culmination of 6,000 years of man's allotted rulership.

On the seventh day they marched around Jericho seven times, blowing the trumpets. This corresponds to the blowing of the seventh trumpet of Revelation.

It was on the seventh time around, on the seventh day, that all the people shouted, and the walls fell down flat. Thus

on the seventh day we must multiply 1480 (one time around) by 7, because they marched around seven times.

$$7 \times 1480 = 10360$$

(Phillipians 3:11)

The Resurrection

$$\eta \; \varepsilon \xi \alpha \nu \alpha \sigma \tau \alpha \sigma \iota \varsigma$$

8 + 5+60+1+50+1+200+300+1+200+10+200

1036

(John 11:25)

I am the Resurrection

$$\varepsilon \iota \mu \iota \; \eta \; \alpha \nu \alpha \sigma \tau \alpha \sigma \iota \varsigma$$

5+10+40+10 + 8 + 1+50+1+200+300+1+200+10+200

1036

At the time of the blowing of the seventh trumpet of Revelation, the proclamation is made:

> *"And the seventh angel sounded; and there were great voices in heaven, saying, The kingdoms of this world are become the kingdom of our Lord, and of his Christ; and he shall reign for ever and ever ... and that thou shouldest give reward unto thy servants the prophets, and to the saints, and them that fear thy name."*

Thus the vision that was given to John proclaimed that at the time of the blowing of the seventh trumpet, there would be the conquering and overthrow of man's governments; and there would be a resurrection.

The use of the numbers 7, 1480 and 1036 does not appear to be a random chance. When combined with the whole body of evidence brought to bear thus far, these numbers appear to be part of a Master Plan. And the evidence builds. But first, it will help to have a brief overview of man's time here on this earth.

A careful and detailed study of chronology suggests that the creation of Adam was in the autumn of 4002 B.C. His disobedience and sin took place in the spring of 3968 B.C. Thus 6,000 years from Adam's creation would end in the autumn (Rosh Hashanah) of A.D. 1999. Six thousand years from Adam's disobedience would then be in the spring of A.D. 2033. Graphically it looks like this:

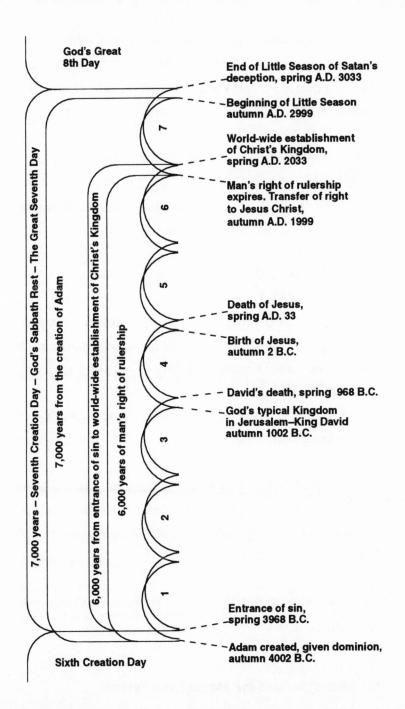

From the above, we see that the entire length of time from the creation of Adam until the end of the "Little Season" is a period of 7,033 years. It was thrilling to find this number in the Gematria of the conquering of Jericho.

7033 = "and the priests shall blow with the trumpets, and it (7032)[1] shall be when they blow long on the ram's horn, shall shout all the people with a great shout, and shall fall the wall of the city down flat."

By the end of 7,033 years from the creation of Adam, the "walls of Jericho" will have been felled. Jesus, earth's rightful Ruler, will have put down and demolished even the last vestiges of the effects of man's mis-rule of the earth. It will be time for the Great Eighth Day – God's Grand Octave – A New Beginning – God's Grand Jubilee!

How appropriate that the trumpets which were blown as they conquered Jericho were ram's horns, *yobel,* Jubilee trumpets.

This grand total of 7,033 years bears the name of Jesus and the "place of salvation" – the earth. The Gematria is so awesome that I simply stand in wonder and amazement. The Master Mathematician has planned it from the beginning.

1 According to the ancient Hebrew use of number substitution, 1 could be added or subtracted without changing the meaning of the number. This is the law of Colel.

$$7033 \div 792 = 8.88$$

Jesus

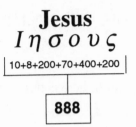

$$10+8+200+70+400+200$$

888

Lord Jesus Christ

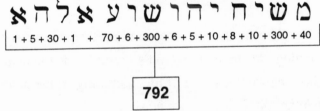

$$1 + 5 + 30 + 1 \quad + \quad 70 + 6 + 300 + 6 + 5 + 10 + 8 + 10 + 300 + 40$$

792

Salvation

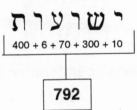

$$400 + 6 + 70 + 300 + 10$$

792

Mean diameter of earth is 7,920 miles

The mean diameter of the earth is 7,920 miles. The numbers are magnificent! Earth is the place of salvation. Earth is the place where Jesus came to pour out His innocent blood to save all of Adam's race. Earth is the place where He comes to reign.

8888 = He must reign until he has put all enemies under his feet (I Corinthians 15:25)

888 = Jesus

888 = destroyed, $\delta\iota\epsilon\phi\theta\alpha\rho\eta\sigma\alpha\nu$ (The last enemy that will be destroyed will be death itself.)

Just like the octave, the number 8 represents a New Beginning. At the end of God's grand week for man, He begins a new era – an era of life, including all the potential that Adam possessed before he sinned.

7033 years
x
pi (3.14159)
÷
earth's mean circumference (24881.392)
=
888

When we multiply 7033 years by *pi* (3.14159) we make a circle of time, just like the marching around Jericho was a circle that represented the entire 7033 years. Divide that vast circle of time by the circle of earth's mean circumference, and the result is 888, which represents Jesus and His righteous rule of earth.

These magnificent numbers are not merely random coincidences – they are beautiful and powerful evidence of a Master Plan. This plan was illustrated by Joshua's marching around Jericho and was prophesied by the vision that was given to John.

This Master Plan was conceived long before the creation of man. Back when the sun, moon and stars were created and set into motion, the plan for man was patterned.

I thank my friend, Neil Pinter, for showing me some of these magnificent patterns.[1]

Today's science defines a light year as the distance light travels in one year, using the rounded figures of 186,000 miles per second for the speed of light, and 365 as the number of days in a year. At 186,000 miles per second, light will travel 16.0704 billion miles in one day. Multiply by 365 days in the year and we obtain the length of one light year, which is 5.865696 trillion miles.

The sun is our source of light. This stream of golden

1 From *Jesus, His Magnificent Name,* by Neil Pinter, Westhaven Publishing, 205 Sarasota St., Borger, Texas 79007, U.S.A.

light goes out in all directions from the sun at the same time.

In one light-year it would reach 5.865696 trillion miles in each direction out from the sun, and would form a sphere of light twice that distance in diameter. To show this on a flat surface we will take a cross section of it.

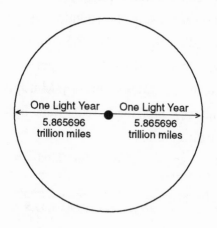

Across the diameter of this sphere of light we would be able to place 1,480 billion earths, using earth's actual equatorial diameter, and placing them side by side, just touching. It is not possible to diagram it here, but the following is an illustration of the idea. There would be, of course, many more earths than I am able to show here.

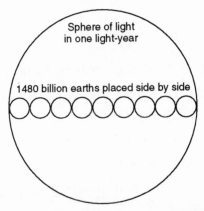

Compare this with Joshua's army marching around Jericho. They went around the city in a large circle.

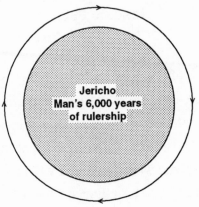

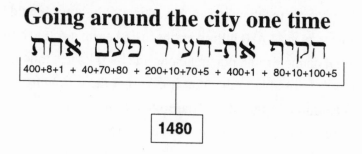

Going around the city one time

הקיף את-העיר פעם אחת

400+8+1 + 40+70+80 + 200+10+70+5 + 400+1 + 80+10+100+5

1480

The city of Jericho represents man's 6,000 years of misrule in the earth. Joshua's army marched around the city for six days, but did not touch the city nor attempt to bring down its wall. Multiply 6 x 1480 and it represents the entire period of 6,000 years and brings us to 888, which pictures Jesus standing with the open scroll – the legal functioning document authorizing right of rulership.

6 x 1480 = 8880
Jesus = 888

The pattern of this was set in the heavens long before man was ever created. This pattern gives the exact same figures. If the diameter of the sphere of one light-year out from the sun will contain 1,480 billion earths, then six light-years will produce a sphere whose diameter will contain 8880 billion earths. It is a pattern fortelling the time when Jesus (888)

stands as earth's rightful ruler – He has ownership of the open scroll by right of purchase.

Then Joshua (representing Jesus) marched around Jericho one more day (the Millinnial Day), making seven days in all. Thus 7 x 1480 = 10360. This is the number for resurrection.

(Phillipians 3:11)

The Resurrection

$$\eta \; \varepsilon \xi \alpha \nu \alpha \sigma \tau \alpha \sigma \iota \varsigma$$

8 + 5+60+1+50+1+200+300+1+200+10+200

1036

(John 11:25)

I am the Resurrection

$$\varepsilon \iota \mu \iota \; \eta \; \alpha \nu \alpha \sigma \tau \alpha \sigma \iota \varsigma$$

5+10+40+10 + 8 + 1+50+1+200+300+1+200+10+200

1036

Seven light-years out from the sun in all directions would produce a sphere of light whose diameter would contain 10,360 billion earths placed side by side. What a magnificent display of God's pattern of time!

Joshua and his army actually marched around the city of Jericho a total of thirteen times – once each of six days, and seven times on the seventh day. How beautiful to find that 13 x 1480 = 19,240. It illustrates the time when earth's Millennial Day is complete. Paul told us of this day, and he described it thus:

> *"Then cometh the end, when he shall have delivered up the kingdom to God, even the Father; when he shall have put down all rule and all authority and power* (Jericho's walls had fallen down flat). *For he must reign till he hath put all enemies under his feet. The last enemy that shall be destroyed is death … And when all things shall be subdued unto him, then shall the Son also himself be subject unto him that put all things under him, that God may be all in all."* (I Corinthians 15:24-28)

The God of the Universe

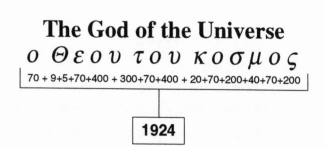

70 + 9+5+70+400 + 300+70+400 + 20+70+200+40+70+200

1924

$$13 \times 1480 = 19{,}240$$

"The day of the Lord" as used in I Corinthians 1:8 also adds to 1924. How appropriate! By some scriptural definitions, the day of the Lord includes the whole of earth's Great Millennium. At its culmination and fulfilment, God will be *"all in all."*

It was on the seventh day that Jericho was conquered. It does not go unnoticed that in the Hebrew text which describes this event, the Gematria gives us the number that represents earth and salvation. It is just one more confirmation, encoded into the original text, telling us that this represents earth's Millennium – the time when salvation and life will be available to all.

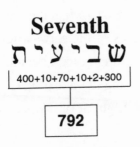

Seventh

שביעית

400+10+70+10+2+300

792

Earth's mean diameter = 7,920 miles

How magnificent is the pattern in the heavens! When King David of old wrote *"The heavens declare the glory of God"* he may not have been aware that he was defining the One who would bring salvation to man.

The heavens declare the glory of God

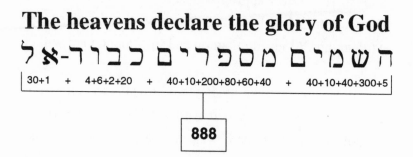

When Abraham was on Mount Moriah and God swore (sevened) an oath to him that through his "seed" all the peoples of the earth would be blessed, little did he know the magnitude of the promise, or that the pattern of the promise to bless all the peoples of the earth would be shown in the heavens, by the unending golden stream of light that pours out from the sun to bring life to earth. That promised "seed" was Jesus. He is the Light of the World!

Jesus = 888

6

The Treasures of Jericho

Jericho is the doorway to the land of Israel. It was so in Joshua's day, and it is still so today. It is reputed to be the oldest city in the land of Israel.

Along the eastern bank of the Jordan river is a rugged mountain range. There are only five passes through these mountains which allow entrance into the land of Israel. Two of these are at Jericho. Thus Jericho has come to be known as "the key to Israel."

Today, entrance into Israel from the east would be at the Allenby Bridge or at the Abdullah Bridge.

It was just opposite Jericho, on the east bank of the Jordan, that Moses was buried.

> *"So Moses the servant of the Lord died there*
> *in the land of Moab, according to the word*
> *of the Lord. And he buried him in a valley*
> (ravine, הגיא) *over against Beth-peor."*
> (Deuteronomy 34:5-6)

It would have been at the place where the wadi broadens into the flood plain of the Jordan.

It was here at the base of the mountain pass, that Joshua led the Israelites across the Jordan.

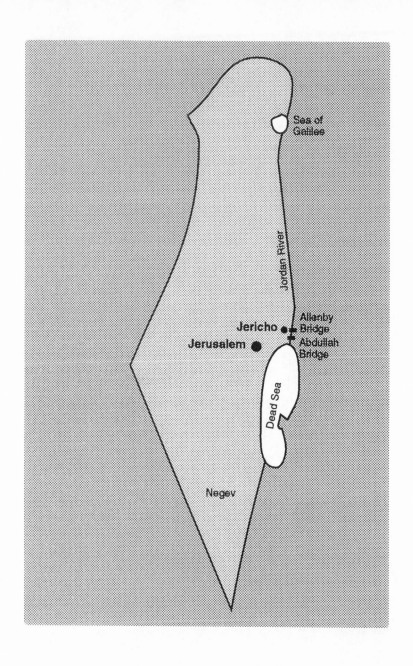

Sea of
Galilee

Jordan River

Allenby
Jericho ● ▆ Bridge
Jerusalem ● Abdullah
Bridge

Dead Sea

Negev

74 Apocalypse and the Magnificent Sevens

It was here also that Elijah was taken up in a whirlwind. It was from here that his companion, Elisha, went back across the Jordan and healed the poison waters of Jericho.

At the ancient city of Jericho was a copious spring, but the waters were undrinkable. They were probably laden with salt, for the city of Jericho is situated 800 feet below sea level. Elisha healed the poison water by throwing salt into it. What a strange way to make salt water fresh!

It was here in the Jordan that Elisha instructed the Syrian army captain, Naaman, to wash seven times (פעמים-שבע = 612), and his leprosy would be healed.

When Nebuchadnezzar's army laid siege to Jerusalem, and marched into the city on the 9th of Av in 586 B.C., Judah's king Zedekiah fled to Jericho. It was here at Jericho that Zedekiah was captured, while the city of Jerusalem and the temple were being burned with fire.

It was in the Jordan, near Jericho, that Jesus was baptized.

It was at Jericho that Jesus healed two blind men (Matthew 20:29-34 and Luke 10:46-52).

It was at Jericho that Jesus said to the tax collector, Zacchaeus, *"This day is salvation come to this house ... for the Son of man is come to seek and to save that which was lost."* (Luke 19:1-10)

It was at Jericho that Jesus spoke his parable of the Good Samaritan.

Some commentaries suggest that Jericho was the oldest city in Israel. Its name means "breath" or "fragrance," probably because of the abundance of its tropical flowers. The Hebrew spelling of this name was ירוחו, which adds to 230.

It speaks of the breath of life that was given to Adam. It began as a fragrance; but when he sinned, it had the stench of death. Its number, 230, is appropriate, because 23 is the Biblical number for death. Its 2 x 3 equals the number of man and his home, the earth – 6. But if we multiply the letter/numbers ירוחו the product is 5760. It is a number that appears to have reference to the time when Jesus stands with the open scroll, the right to rule. And it does not go unnoticed that Rosh Hashanah of 1999 (the end of 6,000 years from Adam's creation) began the Hebrew year 5760.

5760 = Six days, ששת ימים (by multiplication) (The completion of six "days" brings us to the beginning of the year 5760.

5760 = Messiah the Prince, משיח נגיד (by multiplication) (At the beginning of the year 5760, Jesus stands with the open scroll – He is now the Prince because he has the right to rule.)

5760 = I have set my King, נסכתי מלכי (by multiplication) (Psalm 2:6) (Jesus takes His place as ruler of earth.)

5760 = Third day, τριτην ημερα (by multiplication)
5760 = Third day, תלתה יום (by multiplication)
(The importance of the number is emphasized by the fact that "third day" in both Greek and Hebrew will multiply to 5760.)

The "third day" in prophecy has reference to the great seventh day – Earth's Great Millennium. It is sometimes called the "third day" because it begins the third thousand year "day" from the first advent of Jesus.

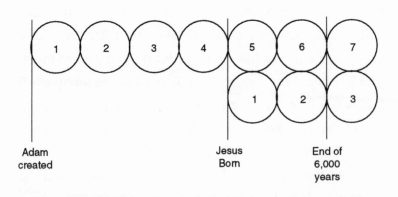

Adam created

Jesus Born

End of 6,000 years

The prophet Zechariah, when speaking of the coming of the One who has the right to rule, used the expression, *"Behold your King."* (Zechariah 9:9) If we multiply the letter/numbers it will produce 6000. At the completion of 6,000 years from the creation of Adam, when man's allotted time to rule has expired, earth's new King stands with the official

document giving Him the right to rule. And God proclaims, *"I have set my king upon my holy hill of Zion."* (Psalm2:6)

Jericho represents man's rulership. It was given to him by God. It began as a lovely fragrance, for that was the meaning of the name, יריחו. However, the spelling of the name was later changed to ירירחו, which means "city of the moon." The place that had lost its fragrance and bore the stench of death, now becomes a place where the reflected light of the sun shines.

The new spelling of Jericho, ירירחו, has a number value of 234. The sum of the digits is 9 (2 + 3 + 4 = 9). It now becomes the number of completion, perfection, fulfillment and finality. Its poison waters have been healed, and it becomes a place of life – a beautiful fragrance once more. The city of Jericho becomes the place of the restoring of all that was lost in Adam. It is, for the purpose of illustration, the whole earth with a perfect government – divine government. The New Jerusalem, at this point in time, will have engulfed the world. Jericho, the city of the moon, will be encompassed by the divine light:

> *"And the city had no need of the sun, neither of the moon, to shine in it; for the glory of God did lighten it, and the Lamb is the light thereof."* (Revelation 21:23)

Jericho was conquered on the seventh day. After they had marched around the city seven times, blowing the seven

trumpets, the people gave a shout and the walls fell down flat. The Hebrew words *"seven times,"* שבע-פעמים, has a number value of 612. The Hebrew word for "covenant," as used throughout the Old Testament, is *brit*, ברית, which also adds to 612. We have seen that according to the ancient Hebrew act of making a covenant, the one making the promise "sevens" himself. Thus when Abraham offered his son, Isaac, on Mount Moriah, God "sevened" Himself.

> *"By myself have I sworn* (sevened myself)
> *... that in blessing I will bless thee and in*
> *multiplying, I will multiply thy seed as the*
> *stars of the heaven and as the sand which is*
> *upon the seashore ... and in thy seed* (Jesus)
> *shall all nations* (peoples) *of the earth be*
> *blessed."* (Genesis 22:16-18)

The marching around Jericho seven times was an act of covenanting – a sworn oath.

612 = Seven times, שבע-פעמים
612 = Covenant, ברית

It accomplished the full destruction of the city of Jericho (man's governments).

> *"At that time Joshua pronounced this solemn oath: Cursed before the Lord is the man who undertakes to rebuild this city, Jericho."*

No, the evil of man's governments will never again be rebuilt. He swore it with an oath – he sevened himself.

The entire city and all that was in it was destroyed, but there were a few specified things saved. They were the "treasures" of Jericho.

That which was saved from Jericho was Rahab and her immediate family, and all the gold, silver, bronze, and iron that could be found in the city. If the city of Jericho represents man's misrule of the earth, then what is the meaning of the few items that were saved?

Because Rahab believed in the God of Israel, and because she had helped the Israelite spies who had come into Jericho, she was given the promise that she and her household would be saved when the city was destroyed. The means by which she and her household would be identified and saved would be a scarlet cord which she would hang in her window.

That cord is called, in the Hebrew text, a *"scarlet thread."* It was the means by which Rahab and her household would be saved from death. It pictures the means by which the entire family of Adam will be saved from death, *i.e.,* by the blood of Jesus Christ. In the Hebrew text, this scarlet thread has a number value of 388. It is a number that is used in the

Gematria of the Bible relating to the time when Jesus stands with the open scroll and takes His right of rulership of earth. It is said of Him that He would sit on the throne of His father, David. It is the time for the blowing of the seventh trumpet of the Apocalypse. It is the time for the seventh day of marching around Jericho and blowing the trumpets.

Scarlet Thread

Shiloh comes

The throne of His father, David
τον θρονον Δαυιδ του πατρος αυτου

To sound a trumpet

חצר
200+90+90+8

388

There is another hidden meaning involved with the saving of Rahab. During the time of man's rulership of earth, a very special class is "called out" to be the Bride of Christ. They are believers who are said to be "saved by grace." It is generally recognized that the number 5 speaks of divine grace.

Her name was Rahab

שמה רחב
2+8+200 + 5+40+300

555

However, the word "grace" as it is used throughout the New Testament bears the Gematria of 911 – the universal call for help.

Grace

χ α ρ ι ς
600+1+100+10+200

911

Although Rahab pictures those who were saved out of this present flawed society of earth, she also pictures all who are saved up to and including the time when Jericho's walls fall down, *i.e.,* the end of Earth's Great Millennium.

In the Old Testament the Hebrew word *shehreeth,* שארית, has the meaning of being a saved remnant. In II Chronicles 36:20 it is translated *"them that had escaped."* It carries the thought of escaping from disaster – being saved out of it. It bears the universal number, 911.

Them that had escaped

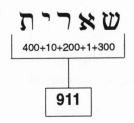

ש א ר י ת

400+10+200+1+300

911

In Revelation, John finishes his testimony with the final words that Jesus spoke to him in the vision:

> *"Let him that heareth say, Come. And let him*
> *that is athirst come. And whosoever will, let*
> *him take the water of life freely ... the grace*
> *(χαρις = 911) of our Lord Jesus Christ be*
> *with you all. Amen."*

When Jericho's walls fell down flat, Rahab and her entire household were saved. It pictures 7,033 years from the creation of Adam, when the last vestiges of the effects of man's misrule are fully demolished.

7033 = "and the priests shall blow with the trumpets, and it shall be when they blow long on the ram's horn (Jubilee trumpet) shall shout all the people with a great shout, and shall fall the wall of the city down flat."

It will be 7,033 years from the creation of Adam. It will be the time for the beginning of the Great Eighth Day – God's Grand Jubilee.

In addition to the saving of Rahab and her household, Joshua was instructed to save all the gold, silver, bronze and iron to be put into the Lord's treasury. This suggests something quite astounding. If these were items involved with man's misrule of the earth, why would they be saved? Of what value would anything of this evil world be to God's perfect Kingdom?

We know that the gold, silver, bronze and iron pertain to the elements of this world of man's governments because God gave King Nebuchadnezzar a dream concerning it, and He gave Daniel the interpretation of it. This is as Daniel described the dream:

"Thou, O king, sawest, and behold a great image. This great image, whose brightness was excellent, stood before thee; and the form thereof was terrible. This image's head was of fine gold, his breast and his arms of silver, his belly and his thighs of brass (bronze), *his legs of iron, his feet part of iron and part of clay. Thou sawest till a stone was cut out without hands, which smote the image upon his feet that were of iron and clay, and brake them to pieces. Then was the iron, the clay, the brass, the silver, and the gold, broken to pieces together, and became like the chaff of the summer threshing floors; and the wind carried them away, that no place was found for them: and the stone that smote the image became a great mountain, and filled the whole earth."* (Daniel 2:31-36)

As Daniel described this to Nebuchadnezzar, he told of the kingdoms of man that would rule the world. These kingdoms were represented by gold, silver, bronze and iron, all of which would be ground to powder and blown away. Then Daniel described to Nebuchadnezzar the glorious outcome:

"And in the days of these kings shall the God of heaven set up a kingdom, which shall never

*be destroyed ... but it shall break in pieces
and consume all these kingdoms, and it shall
stand forever."*

The four metals represent:

Gold –	**beauty/royalty**
Silver –	**health/life giving**
Bronze –	**utility/service**
Iron –	**power/strength**

The elements themselves are precious and God-given, but man's misuse of them ends in destruction. They will, however, be the structure of His glorious Kingdom which will grow and fill the whole earth.

These five elements: gold, silver, copper-tin (bronze), and iron are an integral part of the New Jerusalem – the Kingdom that will grow and fill the earth.

Element	Atomic Number	Atomic Weight
Gold	79	196.967
Silver	47	107.870
Bronze:		
Copper	29	63.54
Tin	50	118.69
Iron	26	55.847
	231	542.914 (543)

The Atomic Numbers bear the numbers of man and the earth (2 + 3 + 1 = 6 and 2 x 3 x 1 = 6).

The Atomic Weights bear not only man's number (5 x 4 x 3 = 60) but also the number of divine government (5 + 4 + 3 = 12), and they also bear the number of the Divine One, 543.

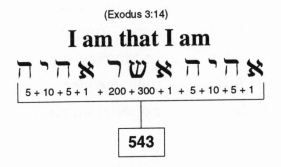

(Exodus 3:14)

I am that I am

אהיה אשר אהיה

5 + 10 + 5 + 1 + 200 + 300 + 1 + 5 + 10 + 5 + 1

543

The New Jerusalem is described as a cube containing 1,728 billion cubic furlongs (12,000 furlongs per side). Let's set them end to end in a straight line and consider it the diameter of a circle. By using $\frac{22}{7}$ for *pi,* as is found in sacred geometry, the circumference of the circle would be 5,430 billion furlongs. It describes God's realm.

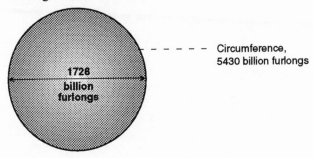

Circumference, 5430 billion furlongs

1728 billion furlongs

This is the reason Joshua was told to collect all the gold, silver, bronze, and iron of Jericho and put it into the Lord's treasury.

The treasures of Jericho are enduring forever. They are the saving of all mankind, and the administration of divine government that is perfect in:

Gold –	**beauty/royalty**
Silver –	**health/lifegiving**
Bronze –	**utility/service**
Iron –	**power/strength**

7

The Man Who Went Down to Jericho

Jericho is a tropical city. It is situated about 800 feet below sea level, in the deep rift through which the Jordan flows. In the summertime its heat is oppressive.

Jerusalem is situated at about 2,500 feet above sea level, and Jericho is at about 800 feet below sea level. The vertical distance between the two is about 3,300 feet. "As the crow flies" the two cities are about 15 miles apart, however, on foot (if walking in a straight line) the distance would be 15.013 miles. Of course, taking the road is even further.

15 Miles x 5,280 = 79,200 feet
.625 Miles x 5,280 = 3,300 feet
15.013 miles x 5,280 = 7926.864 feet

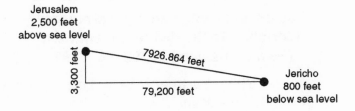

Jerusalem
2,500 feet
above sea level

3,300 feet

7926.864 feet

79,200 feet

Jericho
800 feet
below sea level

> **15.013 miles x 5,280 = 7926.864 feet**
> **792 – 6 – 864**

The numbers tell the story. The ascent from Jericho (man's governments) to Jerusalem (divine government) bears the numbers 792 – 6 – 864. It tells the story of the purpose of Earth's Great Millennium, which is the ascent from man's governments to divine government. The mean distance of earth is 7,920 miles, thus the 792 represents the earth. And 792 is the Gematria for "salvation," showing earth to be the place of salvation. The number 6 represents man. But, joy upon joy, the number 864 is the Gematria for Jerusalem!

Jerusalem
Ιερουσαλημ

> 10+5+100+70+400+200+1+30+8+40

> **864**

> **The ascent from man's governments (Jericho), to the divine government (New Jerusalem) is 792 – 6 – 864.**
>
> **792 – Earth and Salvation**
> **6 – Man**
> **864 – New Jerusalem**

The means whereby this ascent can be made is Jesus Christ, who, at the age of 33, poured out His innocent blood to pay the price for the sin of Adam.

The 3,300 feet difference between Jericho and Jerusalem represents the beautiful fact that man can only make this ascent through the blood of Jesus. The number 3 represents resurrection; and the number 33 represents the means whereby resurrection can take place.

330 = Holy and Just One (Jesus), $\alpha\gamma\iota o\nu$ $\kappa\alpha\iota$ $\delta\iota\kappa\alpha\iota o\nu$

330 = Pain, מצר (through His pain we are healed)

330 = to atone, לכפר

3300 = His throne, $\tau\omega$ $\theta\rho o\nu\omega$ $\alpha\upsilon\tau o\upsilon$ (He is the new Ruler of earth during the Millennium.)

The ascent from Jericho to Jerusalem bears the numbers 792 – 6 – 864. Multiply the digits and the product is 145,152.

$$7 \times 9 \times 2 \times 6 \times 8 \times 6 \times 4 = 145,152$$
$$7 \times 12 \times 12 \times 12 \times 12 = 145,152$$

The number 12 represents divine government, and the use of four twelves in this equation describes the period of the Millennium when testing, probation, and judgment will be accomplished. This is the Biblical meaning of 4 and 40.

The 792 relates to the earth and 864 relates to the New Jerusalem – divine government. The 6 relates to man, thus:

> **6 x 864 = 5184**
> **6 x 792 = 4752**
>
> **5184**
> **−4752**
> **432**

All Things (universal)

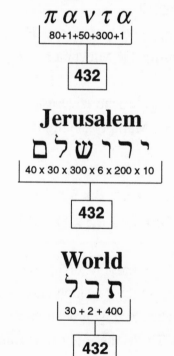

$$\pi\,\alpha\,\nu\,\tau\,\alpha$$

| 80+1+50+300+1 |

432

Jerusalem

ירושלם

| 40 x 30 x 300 x 6 x 200 x 10 |

432

World

תבל

| 30 + 2 + 400 |

432

Hold on! I hear someone saying, "Yeah, but you can do anything with numbers." Not so! Mathematics is an exact science. Jesus obviously knew the meaning and the relationship of Jericho to Jerusalem because He told a very poignant story about a man who went down to Jericho.

"A certain man went down from Jerusalem to Jericho, and fell among thieves, which stripped him of his raiment, and wounded him, and departed, leaving him half dead. And by chance there came down a certain priest that way; and when he saw him, he passed by on the other side. And likewise a Levite, when he was at the place, came and looked on him, and passed by on the other side. But a certain Samaritan, as he journeyed, came where he was: and when he saw him, he had compassion on him, and went to him, and bound up his wounds, pouring in oil and wine, and set him on his own beast, and brought him to an inn, and took care of him. And on the morrow when he departed, he took out two pence, and gave them to the host, and said unto him, Take care of him; and whatsoever thou spendest more, when I come again I will repay thee." (Luke 10:30-35)

The man who went down to Jericho was Adam. He *"fell among thieves"* – Satan was the thief who robbed him and left him half dead. Adam came under the influence of the thief, Satan, who stripped him of his clothes, which in the symbology of the scriptures represents justification. Adam lost his righteousness. The sad tale is told in Gensis 3:7-11:

> *"And the eyes of both of them were opened, and they knew that they were naked, and they sewed fig leaves together, and made themselves aprons. And they heard the voice of the Lord God walking in the garden in the cool of the day: and Adam and his wife hid themselves from the presence of the Lord God amongst the trees of the garden. And the Lord God called unto Adam, and said unto him, Where art thou? And he said, I heard thy voice in the garden, and I was afraid, because I was naked; and I hid myself. And he said, Who told thee that thou wast naked? Hast thou eaten of the tree, whereof I commanded thee that thou shouldest not eat?"*

In the story, the man who went down to Jericho was as good as dead. If help had not come, he would have died.

While the traveler lay there dying, a priest and a Levite came along. As they drew near, and saw the plight of the

poor victim lying there covered with mud and blood, they moved over to the other side of the road, and hurried past, not doing anything to help him. Just so, the sacrifices of the Law, which were in the hands of the priest and Levites, were completely unable to help fallen man or to heal his wounds.

> *"For the law having a shadow of good things to come, and not the very image of the things, can never with those sacrifices which they offered year by year continually make the comers thereunto perfect. For then would they not have ceased to be offered? Because that the worshippers once purged should have had no more conscience of sins. But in those sacrifices there is a remembrance again made of sins every year. For it is not possible that the blood of bulls and of goats should take away sins."* (Hebrews 10:1-4)

But along came the Good Samaritan! He saw the traveler suffering certain death and he had compassion on him. The Good Samaritan is Jesus. He bound up his wounds, poured oil and wine on him to clean off the blood and mud, and to soothe his aching body. It describes the work of redemption. It pictures the work of the spirit (oil and wine) in transforming the sinful nature back into that which can be acceptable to God.

The Good Samaritan put the traveler on His *"own beast,"* which means that the Good Samaritan walked while the injured man rode on the donkey. It is a beautiful picture of Jesus giving himself for Adam – taking the sinner's place. He brought the man to a place where he could be cared for. It shows that the work of atonement is to heal mankind from Adamic sin.

The identification of *"his own beast"* is revealed by the Gematria. The word *"own"* adds to 144 – a number that always identifies God's realm. This means that the One who came to make atonement was in God's realm. However, when we add the numeric value for *"own beast"* it totals 792. It is describing the place of salvation – the earth. Thus the placing of the traveler on His own beast is telling of the salvation of man by means of the sacrifice of Jesus. who came to earth, the place of salvation.

Own = 144
Beast = 648
792

7,920 miles, diameter of earth
792 = Salvation
792 = Lord Jesus Christ
79,200 feet, aerial distance from Jericho to Jerusalem

No, we certainly cannot do just anything with numbers. But even if we could, we could never have devised such remarkable relationships. It's out of our league. It is so obviously the work of the Master Mathematician that we can only stand in awe.

But it is not the end of the story. The Good Samaritan brought the traveler to an inn so he could be cared for. He gave the innkeeper *"two pence"* to pay for his care, and assured him that if there were any additional costs He would pay them when He returned. The numeric value of *"two pence"* is also 648, the same as the value of *"beast,"* thus we have the corresponding price, paid for the traveler.

Two pence was two day's wages. It provides a possible chronological significance. Could it have reference to the two "days" from the first advent of Jesus to His coming again?

The two pence was enough to take care of the traveler for two months at the inn. That would be 60 days. It could possibly have reference to the 6,000 years from the wounding of the traveler (Adam) to the return of the Good Samaritan.

"When I come again I will repay." The Good Samaritan reveals here that He plans to return to get the traveler. The numeric value of *"I will repay"* is 2000. Perhaps Jesus is suggesting here that His return will be 2,000 years after his first advent. Whether or not a time prophecy is implied here, it is certain that Jesus indicated by this story that He

would indeed return for the traveler (Adam). You cannot return to a place where you have never been. He was talking about coming again to earth.

Jesus said *"when I come again"* I will repay. The Greek words used here may indicate the time of that return. The literal Greek text reads *"in the return."* The words *"in the,"* $\varepsilon \nu \ \tau \omega$ multiply to 6000, dropping the rest of the zeros. And *"return,"* $\varepsilon \pi \alpha \nu \varepsilon \rho \chi \varepsilon \sigma \theta \alpha \iota$, multiplies to 54, dropping the rest of the zeros. If not planned, it certainly is a rather convenient coincidence. The number 54 in the Gematria of the Bible appears to have reference to the time of the end of man's rule and the time for the ushering in of the Kingdom of God.

6000 = King, $\beta \alpha \sigma \iota \lambda \varepsilon \iota$ **(by multiplication)**
6000 = Kingdom, $\beta \alpha \sigma \iota \lambda \varepsilon \iota \alpha$ **(by multiplication)**
6000 = Behold your King, הנה מלכך
 (by multiplication)

5040 = The Kingdom of our Lord and His
 Christ (Revelation 11:15)
 (by addition)
5040 = Seventh day, יום השביעי
 by multiplication)
5040 = Until Shiloh comes (Gen. 49:10)
 (by multiplication)

8

The Seventh Trumpet

In the spring of 1002 B.C., David was anointed king over all Israel. That included the northern as well as the southern sectors. In the autumn of that year, he conquered the Jebusite city (Jerusalem) and moved the seat of government there. It was God's typical kingdom – an earthly representative of His divine government. David ruled in Jerusalem for 33¹/₂ years. Prior to his death, he anointed his son, Solomon, to be his successor on the throne.

Solomon's reign began in glory and power. He built the temple and brought all Israel into the worship of God as their Sovereign. But his marriage to foreign wives brought with it the worship of other gods, and the deterioration of his empire.

Upon Solomon's death, Israel was again divided. Jerusalem and the southern environs continued the Davidic monarchy, but the northern portion desired their own king.

Both the northern and southern kingdoms fell into idolatry, sinfulness and evil practices. By the year 721 B.C. the northern kingdom of Israel was taken captive by Assyria, and the people deported.

Finally, by 586 B.C., the Babylonian army had Jerusalem surrounded; the people inside were starving, and they

knew it was merely a matter of a very short time before they all faced death. The king, Zedekiah, was a proud young man, and had strayed far from God's law. On a summer night in 586 B.C., Zedekiah and his army decided to "run for it." They broke down a small portion of the city wall and attempted to escape under cover of darkness. They headed for the low country of the Jordan flood plain, where escape would be the most advantageous. But Nebuchadnezzar's army was on guard, and discovered the attempt at escape. Finally, Zedekiah, the last king of Judah (the Davidic line), was captured at Jericho. He watched while his sons were killed, then his eyes were put out, and he was taken prisoner.

Meanwhile, far away in the capital city of Babylon, a Hebrew priest who had been taken captive a few years previously, was given a message from God. The priest was Ezekiel.

The message he received was God's pronouncement of doom upon the nation of Judah and its wicked Zedekiah. The message was this:

> *"And thou, prophane wicked prince of Israel, whose day is come, when iniquity shall have an end, Thus saith the Lord God; Remove the diadem, and take off the crown: this shall not be the same: exalt him that is low, and abase him that is high. I will overturn, overturn, overturn it: and it shall be no more, until he*

come whose right it is; and I will give it him."
(Ezekial 21:25-27)

That right of rulership was displayed to John when he saw Jesus standing with the open scroll (right of rulership) in His hand; and He lifted up His hand to heaven and made a sworn oath that "time is up" for man's rulership of the earth. He *"whose right it is"* has taken the authority! He not only has the rulership of earth by right of purchase, He also has the additional right to be the great and final successor to the throne of David by right of inheritance.

This is the great pivotal event in the entire book of Revelation. What John saw following that event is exciting.

As He stood there with one foot on the land and the other foot on the sea, He said to John:

> *"But in the days of the voice of the seventh angel, when he shall begin to sound, the mystery of God (the Bride) should be finished."*

Then, as John watched the vision, the scene changed. He saw *"two witnesses"* who were to prophesy 1,260 days, clothed in sackcloth (a sign of mourning). John was told, *"These are the two olive trees, and the two candlesticks standing before the God of the earth."* They were light-bearers.

Then John heard a description of these two witnesses:

> *"These have power to shut heaven, that it rain*

> *not in the days of their prophecy: and have*
> *power over waters to turn them to blood, and*
> *to smite the earth with all plagues, as often*
> *as they will."*

Withholding the rain was the work of Elijah. And turning water into blood and smiting the earth with plagues was the work of Moses.

These same two men were identified in the prophecy of Malachi, placing them in the same time frame as John's vision.

> *"Remember ye the law of Moses my servant,*
> *which I commanded unto him in Horeb for*
> *all Israel, with the statutes and judgments.*
> *Behold, I will send you Elijah the prophet*
> *before the coming of the great and dreadful*
> *day of the Lord."*

Because of this identification, many today believe that the two witnesses are the resurrected Moses and Elijah. Let me suggest one step further in the analogy.

Moses represented the Law. Elijah represented the prophets. Perhaps this is the reason that the message given just prior to, and up to, the time of the blowing of the seventh trumpet is described as Moses and Elijah – this message is in reality the *"Law and the Prophets."* It is the entire testimony of the scriptures. It is the message on the lips of

those faithful ones who will be *"caught up"* at the time of the blowing of the seventh trumpet.

When Jesus referred to the *"Law and the Prophets,"* He included the Psalms, which were the first book of what was called the "Writings." The Hebrew Bible is thus divided into these three sections: The Law, The Prophets and The Writings. Jesus indicated that the entire Law, Prophets and Writings prophesied concerning Him.

The Apostle Paul summed it up in one succinct statement:

> *"But now the righteousness of God ... is manifested, being witnessed by the Law and the Prophets; even the righteousness of God which is by faith of Jesus Christ unto all and upon all them that believe."* (Romans 3:21-22)

The Law and the Prophets is the whole testimony of the scriptures – it is the message of those who have brought this witness to all the world.

John said that the message of these two witnesses was given in *"Sodom and Egypt, where also our Lord was crucified."* And he added that the bodies of these two witnesses would lie dead there. Now those who interpret Revelation literally, would have a hard time convincing us that Jesus was crucified in either Sodom or Egypt. In fact, the city of

Sodom had gone out of existence a couple of millennia before Jesus was crucified. But it is not a book of literal places and events – it is a book of "signs." And Sodom and Egypt are signs of the godless, unbelieving world who crucified Jesus and persecuted His followers; and are now putting to death the God-given message contained in the *"Law and the Prophets."*

These faithful believers, who live in the days when this message lies dead in the streets of Sodom and Egypt, are delivered when they hear the voice from heaven saying, *"Come up hither."*

> *"And after three days and a half the spirit of life from God entered into them ... and they heard a great voice from heaven saying Come up hither."* (Revelation 11:11-12)

This is when the seventh trumpet sounds!

> *"And the seventh trumpet sounded; and there were great voices in heaven, saying, The kingdoms of this world are become* (past and present tense) *the kingdom of our Lord, and of his Christ* (the One Anointed to be King) *and he shall reign for ever and ever. And the four and twenty elders, which sat before God, fell upon their faces, and worshipped God, saying, We give thee thanks, O Lord God*

*Almighty, which art, and wast, and art to
come; because thou hast taken to thee thy
great power* (the right of rulership in the hand
of Jesus) *and hast reigned* (the legal rulership
begins <u>before</u> the sounding of the seventh
trumpet.") (Revelation 11:15-17)

As seen in the outline of Revelation shown on page 54,
the pivotal event of Jesus standing with the open scroll pre-
cedes the ending of the testimony of the two witnesses; it
precedes the completion of the Bride and the call to *"Come
up hither,"* and it precedes the pouring out of the bowls of
wrath and the casting out of the great whore. But it begins
the seventh day from the creation of Adam.

Jesus stands with the open scroll (a functioning legal document) at the expiration of man's 6,000 years, and at the beginning of a seventh thousand-year day. But remember, we are counting from the time when dominion was given to Adam in the Garden of Eden, before sin entered. The time gap of 33$\frac{1}{2}$ years between his creation and his sin is, of necessity, repeated at the end of 6,000 years. It is the same time gap as existed between the beginning of David's typical kingdom in Jerusalem, and his death; and it is the same time gap as was between the birth of Jesus and His death.

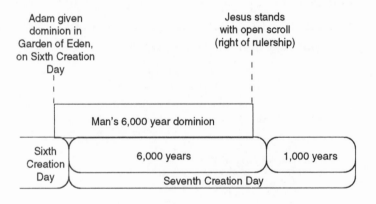

It becomes apparent that the 6,000 years of man's allotted rulership does not begin and end precisely with the beginning and ending of the first 6,000 years of the Seventh Creation Day.

The Seventh Creation Day began with the ending of the Sixth Creation Day. Adam was created on the Sixth

Creation Day. Sin entered at the point of juncture between Creation Days Six and Seven. The difference between the two is apparently 33^{1}/$_{2}$ years. This figure is obtained from the human life span of Jesus, the Second Adam. If Adam lived in perfection in the Garden of Eden for 33^{1}/$_{2}$ years, then the 33^{1}/$_{2}$ years in which Jesus lived in perfection corresponds precisely. At the end of Adam's 33^{1}/$_{2}$ years in perfection, he sinned, thereby forfeiting his life rights. At the end of Jesus' 33^{1}/$_{2}$ years of perfection, He offered His life as a payment for the sin of Adam, having become the precise substitute for Adam.

Thus from the creation of Adam to the birth of Jesus was exactly 4,000 years; and the time from the sin of Adam to the death of Jesus was also exactly 4,000 years.

By extrapolation, it becomes apparent that if 6,000 years from the creation of Adam ends with Rosh Hashanah of A. D. 1999, then the ending of 6,000 years of the Seventh Creation Day would be in the spring of A.D. 2033. That date point will begin Earth's Great Millennium – the final 1,000 years of the Seventh Creation Day.

Do we have anything in the Bible to confirm this? Yes!

Confirmation can be found in Israel's sacred year. It was the span of seven months, during which their seven divinely appointed sacred festivals occurred. It was God's "Week of Months," beginning with Nisan in the spring, and ending with Tishri in the autumn. These seven festivals are:

1. **Passover (Nisan 14)**
2. **Unleavened Bread (Nisan 15-21)**
3. **Firstfruits (Nisan 16)**
4. **Pentecost (Sivan 6)**
5. **Trumpets (Tishri 1)**
6. **Atonement (Tishri 10)**
7. **Tabernacles (Tishri 15-21)**
 (Followed by the great eighth day celebration
 called "the Atzereth," meaning "conclusion.")

Three of these festivals were to be celebrated in a very special way. All the males were to present themselves to God. The instructions given to Moses and recorded in the Torah are as follows:

> *"Three times thou shalt keep a feast unto me in the year. Thou shalt keep the feast of unleavened bread ... and the feast of harvest of firstfruits of thy labors, which thou hast sown in the field; and the feast of ingathering, which is in the end of the year, when thou hast gathered in thy labours out of the field."*
> (Exodus 23:14-16)

> *"Three times in a year shall all thy males appear before the Lord thy God in the place which he shall choose; in the feast of unleavened bread, and in the feast of weeks, and in*

the feast of tabernacles." (Deuteronomy
16:16)

These three feasts came to be known as the Pilgrim Festivals because those who lived in other cities, and even in other countries, came to Jerusalem to celebrate and to present themselves to God at the Temple.

These three Pilgrim Festivals are types, or pictures, of three great epochs of time during man's experience with sin and the redemption from its penalties. And they confirm the time.

The Apostle Paul told us that *"Death reigned from Adam to Moses."* How do we know to what year in Moses' life Paul was making reference? After all, Moses lived 120 years. May I suggest that the year referred to was the year when Moses was instructed to have each Israelite household kill a lamb and sprinkle its blood around the door frames of their houses, thereby saving the lives of those who dwelt within. The death angel was to pass through the land that night, and all of the "firstborn" who were "under the blood" would be saved. The angel would "pass over" the house with the blood. Thus the event came to be known as the Passover.

The death of the lamb was a type, or illustration, of the death of Jesus – and the saving blood of the lamb was a type of the saving blood of Jesus Christ.

The event took place on the 14th of Nisan in the year 1448 B.C. I suggest this was the event and the date that Paul

had in mind when he said *"Death reigned from Adam to Moses."*

If Adam's sin took place 33¹/₂ years after his creation, it would place it in the spring of 3968 B.C. If death reigned until the first Passover in 1448 B.C., the span of time between the two dates would be 2,520 years.

"Death reigned from Adam to Moses"

2,520 Years

Adam's sin
3968 B.C.

First Passover
1448 B.C.

This span of 2,520 years was a total of 1,656 years from Adam's sin to the great Flood, plus 864 years more to the first Passover.

From the first Passover in the spring of 1448 B.C. to the death of Jesus, the great antitypical Passover Lamb, was a span of 1,480 years.

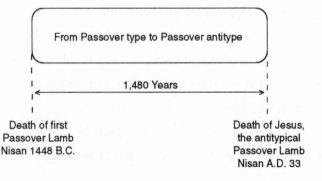

From Passover type to Passover antitype

1,480 Years

Death of first
Passover Lamb
Nisan 1448 B.C.

Death of Jesus,
the antitypical
Passover Lamb
Nisan A.D. 33

Thus the "Passover Age" was a span of 1,480 years. This was the fulfillment of all that was celebrated in the first Pilgrim Festival. Even the numbers tell the story.

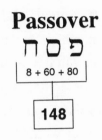

Passover

פ ס ח

8 + 60 + 80

148

Christ

Χριστος

600+100+10+200+300+70+200

1480

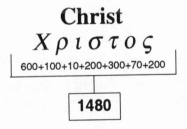

1,480 years between the death of the typical lamb and the death of the antitypical Lamb.

The second Pilgrim Festival was on the 6th of the month Sivan. The Israelites called it the "Feast of Weeks," but in the New Testament it was called "Pentecost." They were to

count seven weeks from the day of Firstfruits, making 49 days, and the following day would be Pentecost.

On this day they went into the wheat fields, which were newly ripening, and cut a measure of the firstripe wheat, removed it from the chaff, ground it to flour, and baked two small loaves, with leaven, which they presented to God.

This was done on the 6th day of the month Sivan, 50 days after the offering of the firstfruits of the barley harvest. The count from the day of Firstfruits was to be seven weeks, or 49 days. The following day would be the day of the offering of the firstfruits of the wheat harvest.

This began to have its fulfillment in the year A.D. 33, just 50 days after the resurrection of Jesus. It was the day of Pentecost, when a very special demonstration of God's power was given to the little band of disciples who were still mourning and in bewilderment after the death of Jesus.

People from many other countries were in Jerusalem that day, because it was one of the Pilgrim Festivals, and they had come in response to the law that Moses had given to them, to present themselves to God at the Temple. And when they heard about the gathering of the disciples, they came to see what was going on.

What they witnessed was the espousal of the Bride of Christ. It came in the form of a pouring out of the Holy Spirit upon the disciples. Those who were teaching suddenly had the ability to speak in the languages of all those who

were in attendance. And there appeared over their heads what looked like tongues of fire. The people were in great astonishment at what they were seeing and hearing.

They each heard a discosurse in their own language – a discourse telling them about the resurrection of Jesus. They were profoundly struck by the intensity of the words, and after they had heard all, they began to ask, *"What shall we do?"*

Peter said, *"Repent and be baptized, every one of you, in the name of Jesus Christ."*

> *"And they that gladly received the word were baptized: and the same day there were added unto them about three thousand souls."* (Acts 2:41)

It was the beginning of a new age – the Pentecost Age. It was the beginning of the period of time that God had planned for the call and development of the bride of Christ. It began with the conversion of 3,000 people, probably all Israelites, for it was from among those who had come to celebrate the Pilgrim Festival of Pentecost.

The Passover Age had come to a close when Jesus hung on the cross, and shed His innocent blood in the place of the guilty blood of Adam. It had marked 4,000 years from the day when Adam sinned. Now a new age was beginning. It was the Pentecost Age. But how do we know how long this age would be?

Look at the type. On the *"morrow after the Sabbath"* they were to harvest the very first ripe barley, and wave it before God as an offering. This was the festival of the Day of Firstfruits. It corresponds to the day when Jesus was raised from the tomb and presented the merit of His sacrifice to God – into the hands of Justice. It was the presentation of the blood that was offered in payment for the sin of Adam. Jesus' resurrection was thus the fulfillment of the Day of Firstfruits type. From this day they were to count 49 days, or seven weeks. Then the next day, the 50th, would be the time of harvesting the firstripe wheat, grinding it to flour, and making two small loaves, containing leaven, and wave it before God as an offering.

The antitype is always greater than the type. The antitype is the harvesting of the firstripe wheat (the church, the Bride) and presenting it to God as a complete body. Yes it has leaven. This is because each one who makes up that corporate body comes from the stock of Adam, and is only made acceptable through the blood of Jesus.

Thus we see the first three of the seven festivals were fulfilled by the death and resurrection of Jesus. The 50th day after the resurrection of Jesus, a new age began. It was the Pentecost Age. It was the age for the call and develop-ment of the Bride. And right on time, the espousal did indeed take place, by the pouring out of the Holy Spirit upon the believers on that day in A.D. 33. Three thousand souls

were added to those who were already believers.

How do we know how long the age will be? When will this corporate body of believers, those who will be the Bride of the Lamb, be complete, and the offering of the Pentecost loaves be presented to God?

In the type they were to count 49 days from the day of the offering of the firstfruit of the barley harvest. The type of the Day of Firstfruits was fulfilled by the resurrection of Jesus and the presenting of the merit of His sacrifice to God. Thus it is necessary to begin counting there. But the antitype is always greater than the type. In the antitype, those 49 "days" are greater periods of time than just 24-hour days as in the type. So let's look for clues.

When this law of the counting from the Day of Firstfruits to the day of Pentecost was given to Moses, it was not possible for them to observe it, because they were in the wilderness where there was no barley or wheat harvest. It was not until 40 years later that they were able to fulfill the requirement of the Law, after they had crossed over the Jordan and come into Canaan. Thus the suggestion that each of these days of counting from Firstfruits to Pentecost, in the antitype, would represent a span of 40 years.

Another hint that each of these days represents a period of 40 years can be found in the length of time of the reign of Saul, Israel's first king. His reign, in some aspects, represents the development of the Church. He began his reign in

humility and sincerity of purpose, but as he grew in power, he also grew in self-importance. It pictures the experience of the Church, which began in humility and sincerity, and in faithfulness to God. But as the years progressed, they became proud, and became the rulers of nations, until it became known as the Holy Roman Empire. It was the Church who crowned and uncrowned kings. It was the Church who persecuted those believers who still lived in humility and faithfulness, burning them at the stake, stretching them on the racks, and beheading them with the guillotine. And, after Saul had reigned for 40 years, he fell on his own sword and died. Thus will come the demise of that which claims to be the Church. As a corporate body, it began with a small group of faithful believers at Pentecost in A.D. 33, but it grew to great power and unfaithfulness. There were, however, individuals who remained faithful.

Saul's 40 years aptly picture the fall from faithfulness during the Pentecost Age. Thus it is suggested that Saul's 40 years represents one "day" of counting from Firstfruits. Multiply 40 x 49 and we arrive at 1,960 years, bringing us up to the great antitypical day of Pentecost, which would be a space of 40 years. If each of the "days" of counting were 40 years, then the "day" which followed would also be 40 years. So let's do the math.

The Pentecost Age began in the spring of A.D. 33. Counting 1,960 years from then would bring us to the spring

of A.D. 1993. This would be the counting of the 49 "days" from Firstfruits to Pentecost. But it was the 50th day that was the day of Pentecost. That was the day that the two wheat loaves were presented to God.

By this analogy, the great antitypical Day of Pentecost would be the 40 years from the spring of 1993, bringing us to the spring of 2033.

This gives us a window of time during which the Bride is complete, the presentation and the wedding take place. And it also gives us a firm confirmation of the date-point A.D. 2033.

By two entirely different methods of counting, the spring of A.D. 2033 appears to be a marked date. It will be the ending of the first 6,000 years of the Seventh Creation Day, and it will also be the ending of the antitypical Day of Pentecost. It is confirmation that Earth's Great Millennium will begin in the spring of A.D. 2033.

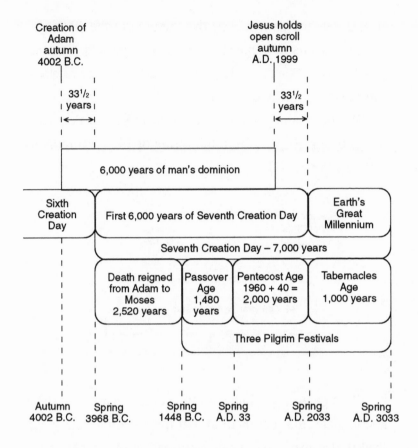

The time sequence in the book of Revelation suggests that the sounding of the seventh trumpet would soon follow the scene of the open scroll. The exact time between the two events is not given, but its nearness is exciting. It appears to be very soon after the transfer of the right of rulership, for other scriptures tell us that the marriage of the Bride and the Lamb will take place, and His Bride comes with him to do

the work of overthrowing man's governments.

Immediately following the heavenly wedding, John saw Jesus riding on a white horse, coming to make war with the kings of the earth.

> *"And I saw heaven opened, and behold a white horse; and he that sat upon him was called Faithful and True, and in righteousness he doth judge and make war ... he was clothed with a vesture dipped in blood; and his name is called The Word of God. And the armies* (the Bride) *which were in heaven followed him upon white horses, clothed in fine linen, white and clean* (they had just received these white robes at the wedding). *And out of his mouth goeth a sharp sword, that with it he should smite the nations: and he shall rule them with a rod of iron: and he treadeth the winepress of the fierceness and wrath of Almighty God. And he hath on his vesture and on his thigh a name written, KING OF KINGS AND LORD OF LORDS."* (Revelation 19:11-16)

This indicates that Jesus is the rightful ruler, that His Bride is with Him, that the wrath of God is poured out, and that He is indeed the *"King of Kings and Lord of Lords."*

There are companion scriptures to this which tell the same story. One of them is Psalm 2.

> *"The kings of the earth set themselves, and the rulers take counsel together, against the Lord, and against his anointed, saying, Let us break their bands asunder, and cast away their cords from us. He that sitteth in the heavens shall laugh: the Lord shall have them in derision. Then shall he speak unto them in his wrath, and vex them in his sore displeasure. Yet have I set my king upon my holy hill of Zion. I will declare the decree: the Lord hath said unto me, Thou art my Son; this day have I begotten thee. Ask of me, and I shall give thee the heathen for thine inheritance, and the uttermost parts of the earth for thy possession. Thou shalt break them with a rod of iron; thou shalt dash them in pieces like a potter's vessel."*

Note the time setting in the above prophecy. It is when *"I have set my king upon my holy hill of Zion,"* meaning that Jesus, at this point in time, is the promised heir to the throne of David, and His rule has begun. Also note that it is the time of God's wrath: *"Then shall he speak unto them in his wrath."* It is the time of the pouring out of the seven bowls of wrath.

Another text indicating that the Bride is with Him when the kings of earth make war against Him is in Revelation 17. After describing the great whore, and the beast that she rides upon, John then describes the battle.

> *"And the ten horns which thou sawest are ten kings ... these shall make war with the Lamb, and the Lamb shall overcome them: for he is Lord of lords, and King of kings: and they that are with him are called, and chosen, and faithful."*

This plainly tells us that the Bride is with Him when He does battle with the kings of earth. It also tells us who wins the battle.

In Revelation 14 is described two harvests. This relates to the harvest of the Pentecost Age, and the harvest of the Tabernacles Age. Pentecost was the time of wheat harvest, and Tabernacles was the time of grape harvest.

It was on the morning of the day of Pentecost, the 50th day, that they went out into the wheat fields and gathered the firstripe wheat for an offering to God. The antitypical 50th day is 40 years in length. At some time near the beginning of that 40-year day, the wheat (the Bride) will be gathered, and presented to God.

At the close of the Pentecost Age, the Tabernacles Age begins. It is the gathering of the grapes and putting them into the winepress. But when John saw this in vision, it was

not grape juice that came out of the winepress, it was blood.

"And I looked, and behold a white cloud, and upon the cloud one sat like unto the Son of man, having on his head a golden crown (his rulership had officially begun), *and in his hand a sharp sickle. And another angel came out of the temple, crying with a loud voice to him that sat on the cloud, Thrust in thy sickle, and reap: for the time is come for thee to reap; for the harvest of the earth is ripe* (dry harvest – wheat – Pentecost offering). *And he that sat on the cloud thrust in his sickle on the earth; and the earth was reaped. And another angel came out of the temple which is in heaven, he also having a sharp sickle. And another angel came out from the altar, which had power over fire; and cried with a loud cry to him that had the sharp sickle, saying, Thrust in thy sharp sickle, and gather the clusters of the vine of the earth* (wet harvest – Tabernacles); *for her grapes are fully ripe. And the angel thrust in his sickle into the earth, and gathered the vine of the earth, and cast it into the great winepress of the wrath of God* (identifying it as the time of God's wrath). *And the winepsress was trod-*

den without the city, and blood came out of
the winepsress ..."

Immediately before these two events take place, the
seventh trumpet sounds. It is sometime on the great
antitypical Day of Pentecost that the seventh trumpet sounds.
According to the math, that 40-year day was due to begin
with the spring of 1993. The trumpet could not be blown at
that time because man's 6,000 years of allotted rulership
had not yet expired. With the arrival of Rosh Hashanah of
A.D. 1999, the stage is set, the players are in their places,
and the Maestro steps up to the podium.

> *"And the seventh angel sounded: and there*
> *were great voices in heaven, saying, The king-*
> *doms of this world are become the kingdom*
> *of our Lord, and of his Christ, and he shall*
> *reign for ever and ever."* (Revelation 11:15)

Then immediately John heard, *"The nations were
angry,"* because the time of God's wrath had come. That
wrath is described in Revelation 15 and 16.

I have heard some who attempt to give a literal inter-
pretation to the bowls of wrath, but John begins by remind-
ing us that they are "signs."

> *"And I saw another <u>sign</u> in heaven, great and*
> *marvelous, seven angels having the seven last*
> *plagues; for in them is filled up the wrath of*
> *God." (Revelation 15;1)*

On page 76 I have shown the ending of 6,000 years of man's right of dominion to begin the Hebrew year 5760, and the confirmation of the date by the following Gematria:

5760 = Six days, שׁשׁת ימים (by multiplication) (The completion of six "days" brings us to the beginning of the year 5760.)

5760 = Messiah the Prince, משׁיח נגיד (by multiplication) (At the beginning of the year 5760, Jesus stands with the open scroll – He is now the Prince because He has the right to rule.)

5760 = I have set my King, נסכתי מלכי (by multiplication) (Jesus takes His place as ruler of earth.)

5760 = Third Day, יום תלתה (by multiplication)

5760 = Third Day, τριτην ημερα (by multiplication) (The importance of the number is emphasized by the fact that "third day" in both Hebrew and Greek will multiply to 5760.)

I have repeated it here because this important time indicator appears again in Revelation 15:1, suggesting that the time of the pouring out of the bowls of wrath are part of the effect of that transfer of authority, which occurred at the beginning of the Hebrew year 5760.

When working with Gematria it is necessary to use the

text from which the translations are taken. Often words and phrases are turned around when being translated into English. If we go back to the Greek text of Revelation 15:1, it reads:

> *"And I saw another sign in heaven, great and wonderful, angels seven having plagues seven the last because in them was finished the anger of God."*

This last phrase, which I have underlined, has a numeric value of 5760. It reveals the time.

> *"And I heard a great voice out of the temple saying to the seven angels, Go your ways, and pour out the vials* (bowls) *of the wrath of God upon the earth."* (Revelation 16:1)

A brief comparison will reveal that the pouring out of the bowls of wrath is upon the same seven things that were described by the seven trumpets.

The first six trumpets described the horrible elements of 6,000 years of man's misrule of earth. Now, when the transfer of authority has taken place, the first six bowls of wrath are poured out upon them, overthrowing and conquering them.

Observe the description of the six trumpets and the six bowls of wrath, and compare:

1st Trumpet	earth's vegetation burned up	1st Bowl	upon the earth
2nd Trumpet	sea became blood	2nd Bowl	upon the sea
3rd Trumpet	rivers & springs made bitter	3rd Bowl	upon rivers & springs
4th Trumpet	Sun, moon & stars darkened	4th Bowl	upon the sun
5th Trumpet	king Abaddon	5th Bowl	upon throne of the beast
6th Trumpet	Loose the four angels in the river Euphrates	6th Bowl	upon the river Euphrates

It becomes apparent that, just as the six trumpets describe 6,000 years of man's misrule, so the corresponding six bowls of wrath describe their overthrow. These governments will be supplanted by divine government, which is represented by the number 12.

These six elements that define man's governments will be overthrown by divine government. Mathematically, they will be divided by 12. Let's do the math:

1. The earth, $\tau\eta\nu$ $\gamma\eta\nu$... 419
2. The sea, $\tau\eta\nu$ $\theta\alpha\lambda\alpha\sigma\sigma\alpha\nu$ 850
3. The waters, $\tau\sigma\upsilon\varsigma$ $\upsilon\delta\alpha\tau\omega\nu$ 2525
4. The sun, $\tau\sigma\nu$ $\eta\lambda\iota\sigma\nu$... 588
5. The throne of the beast, $\tau\sigma\nu$ $\theta\rho\sigma\nu\sigma\nu$ $\tau\sigma\upsilon$ $\theta\eta\rho\iota\sigma\upsilon$ 2136
6. The great river Euphrates, $\tau\sigma\nu$ $\pi\sigma\tau\alpha\mu\sigma\nu$ $\tau\sigma\nu$ $\mu\epsilon\gamma\alpha\nu$ $E\upsilon\phi\rho\alpha\tau\eta\nu$ 2914

9432

$$9432 \div 12 = 786$$

The way the number 786 is used in the Gematria of the Bible describes this overthrow. It defines the results and effect of man's governments, and the saving of mankind out of it, and the supplanting of divine government. The Gematria is awesome!

786 = Desolations, משׁמרת, (Isaiah 15:6)
786 = Desolated, שׁממרת, (Isaiah 49:8)
786 = I shall cry for help, שׁועתי, (Habakkuk 1:2)
786 = I cried for help, שׁועתי, (Jonah 2:3)
786 = Out of our distress, מצרתנו, ("Out of our distress you shall hear and save" II Chronicles 20:9)

786 = You save, תושׁיע, (Habakkuk 1:2)
786 = You may be saved, תושׁעי, (Jeremiah 4:14)
786 = Deliverance, התשׁועה, (Judges 15:18)
786 = The salvation, ישׁועת, (Isaiah 26:18)
786 = His salvation, ישׁעתו, (Deuteronomy 32:15)

Jesus, earth's new King, will save mankind out of the distress that has come from man's misrule, and He will deliver them into His Kingdom of righteousness.

When the seventh trumpet sounds, the overthrow of man's dominion follows. Likewise, the seventh bowl of wrath is that overthrow.

Just before the seventh bowl is poured out, the nations assemble for battle against the new King; although they probably are not aware of whom they are fighting against. They are fighting for survival. In an effort to hold their dominion together, they attempt One World Government. This gathering together immediately precedes the pouring out of the seventh bowl of wrath.

The seventh bowl of wrath is Armageddon!

> *"And the seventh angel poured out his vial into the air; and there came a great voice out of the temple of heaven, from the throne, saying, It is done. And there were voices, and thunders, and lightnings, and there was a great earthquake* (revolution – change of government) *such as was not since men were upon the earth* (never before had man's rule been conquered by divine government), *so mighty an earthquake, and so great ... and the cities of the nations fell ... and every island fled away and the mountains were not found* (nations small and great overthrown)."
> (Revelation 17:17-20)

Daniel had a vision of this same event. He saw the kingdoms of man's dominion as great and ferocious beasts; and he watched as their dominion was taken away. Then he said:

> *"I saw in the night visions, and behold, one like the Son of man came with the clouds of heaven ... and there was given him dominion, and glory, and a kingdom, that all people, nations and languages should serve him; his kingdom is an everlasting dominion, which shall not pass away, and his kingdom that which shall not be destroyed."* (Daniel 7:13-14)

Joshua had marched his army around Jericho, blowing the trumpet, for six days – just as John saw, in vision, six trumpets blown. Then on the seventh day they marched around Jericho (man's governments) six times, blowing the trumpets (corresponding to the six bowls of wrath), and the seventh time around the city they blew the trumpet (Armageddon), and gave a mighty shout, and the walls fell down flat.

Jericho was conquered!

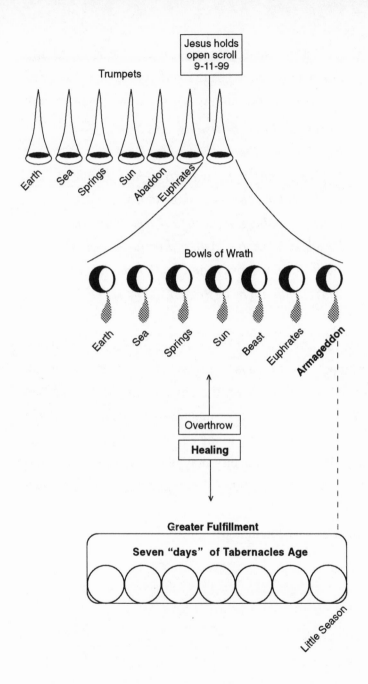

9

The Light of Seven Moons

Jericho was burned to the ground. There would have been nothing left – but, in fact, there <u>was</u> something left. Some of the gold, silver, and a beautiful Babylonian robe were hidden beneath Achan's tent. The loot that Achan buried was called *"the accursed thing."*

"The accursed thing" was buried in the ground at Jericho. The Hebrew word used here, *charam,* חרם, means "devoted" or "devoted to destruction so that it could not be redeemed." (Gesenius' Hebrew and Chaldee Lexicon)

God had instructed Joshua to collect all the gold, silver, bronze, and iron and put it into the treasury of the Lord. And Rahab, along with her entire household were to be saved. These were the treasures of Jericho. The gold, silver, bronze and iron, placed in the Lord's treasury is transformed into the administration of divine government that is perfect in:

> **Gold** – **beauty/royalty**
> **Silver** – **health/lifegiving**
> **Bronze** – **utility/service**
> **Iron** – **power/strength**

And the saving of Rahab and her entire household is the saving of all mankind.

But the roots of man's governments (man's gold, silver, and the glory of Babylon) are buried in the earth. Even though the walls of Jericho fell, the roots of Jericho still remain in the earth, not to be completely destroyed until the end of Earth's Great Millennium. Then, with the loosing of Satan from his thousand-year prison sentence, those roots of man's governments will make an attempt to sprout.

> *"And when the thousand years are expired, Satan shall be loosed out of his prison, and shall go out to deceive the nations which are in the four quarters of the earth, Gog and Magog, to gather them together to battle: the number of whom is as the sand of the sea. And they went up on the breadth of the earth, and compassed the camp of the saints about, and the beloved city* (New Jerusalem); *and fire came down from God out of heaven and devoured them."* (Revelation 20:7-9)

We have seen that the marching around Jericho seven times on the seventh day coincides with the pouring out of the bowls of wrath and the overthrow of man's governments. But, because the roots of those governments (gold, silver and the glory of Babylon) remain buried in the earth, the complete conquering and destroying of the last vestiges of

those governments will not occur until the end of the Millennium. Thus the blowing of the trumpets (*yobel* – Jubilee) around Jericho has the added significance of ushering in God's Grand Jubilee. This is indicated by the Gematria:

7033 = "and the priests shall blow with the trumpets, and it shall be when they blow long on the ram's horn (Jubilee trumpet) shall shout all the people with a great shout, and shall fall the wall of the city down flat."

This final and complete overthrow of the last vestiges of man's governments will come at the end of 7,033 years from the time when dominion was given to Adam in the Garden of Eden. Thus in the larger picture, the greater fulfillment, the blowing of the trumpets around Jericho is a Millennium event, as has been shown in chapter 5.

The original spelling of Jericho was ירוחו, which means "fragrance." As has been shown, that original fragrance soon became the stench of death. Later the spelling was changed to יריחו, which means "city of the moon." Jericho becomes the place where the reflected light of the sun shines. In the place of the old city of Jericho, which bore the stench of death, a new city of life supplants it. The Gematria of יריחו, is 234. Add the digits (2 + 3 + 4) and we obtain 9. Nine is the number that means completion, per-

fection, fulfillment and finality. The poison waters of Jericho will be healed. It's new name, "city of the moon" is apparently part of the Millennium picture.

This picture, of the fall and overthrow of man's governments and the ushering in of Earth's Great Millennium is prophesied succinctly and figuratively in Isaiah 30:25-26.

> *"And there shall be upon every high mountain* (great nations) *and upon every hill* (lesser nations) *rivers and streams of waters* (life-giving truth) *in the day of the great slaughter* (Armageddon), *when the towers fall. Moreover the light of the moon shall be as the light of the sun, and the light of the sun shall be sevenfold, as the light of seven days, in the day that the Lord bindeth up the breach of his people, and healeth the stroke of their wound."*

Jericho becomes the "city of the moon." The light of the moon becomes <u>as</u> the light of the sun, shining seven days. The symbology is beautiful.

The word "moon" is the same as "month," because months were counted by the occurrence of the new moon. In the prophetic time of the scriptures, a month is thirty days. Seven "days" of 30 days each would be a total of 210 days. It appears to represent the time during which the new city of

life, "city of the moon," supplants the old city which bore the stench of death.

Divine government is represented by the number 12. The mirror opposite of 12 is 21. The meanings are the same. Put them together and we have a palindrome – 2112. But there is more to 21 and 12 than might be seen on the surface.

2112 = A virgin shall conceive and bear a son and shall call his name Emmanuel (Isaiah 7:14)

2112 = Seven spirits, $\epsilon\pi\tau\alpha \pi\nu\epsilon\upsilon\mu\alpha\tau\omega\nu$ (Revelation 1:4)

2112 = Glory of the Lord (II Thessalonians 2;14)

The number 2112 was the standard by which Ezekiel's temple was measured; for the Great Cubit is 21.12 inches. The temple that Ezekiel saw in vision represents the meeting place between God and man during the Millennium.

But the numbers 21 and 12 take on meaning that engulfs the whole plan of God for the salvation of man through the Lord Jesus Christ.

The number 37 is the 12th prime. The mirror opposite of 37 is 73, which is the 21st prime. We not only have flipped the 37 but we have also flipped its position among the primes. It all speaks of "life."

370 = My anointed (Messiah), במשיחי

370 = He lives, שכן

370 = He rules, משל

73 = Life *(ha-chiam)*, החיים

The "light of seven days" would bear the number 21 (210) which is the position of the prime number 73, which means "life." This brings life in the ultimate – everlasting life in the fulfillment and finality of God's plan for man, as is represented in the number 9.

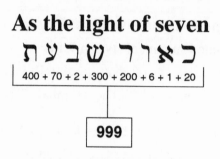

As the light of seven

כ א ו ר ש ב ע ת

400 + 70 + 2 + 300 + 200 + 6 + 1 + 20

999

Let's look briefly at Isaiah 30:25 again, and take note of something which appears to be significant.

*"And there shall be upon every high moun-
tain, and upon every high hill, rivers and
streams of waters in the day of the great
slaughter, <u>when the towers fall."</u>*

Towers

ס ג ד ל י ם

40 x 10 x 30 x 4 x 3 x 40

5760

The "towers" here obviously refer to the high governmental authority which the major nations of the world have obtained. But there were a couple of icons that represented those "towers" of power – they were the twin towers of the World Trade Center. It represented, if you please, exactly what its name implies – towers of world power. These two icons of world power fell on September 11, 2001. The mirror opposite of 12 (divine government) is 21 (2001). The meanings are the same but in this case we have a counterfeit. We have man-made "towers" of world power. They fell in the year 2001, which is the same as 21. But it is not to be overlooked that the month and day was September 11. What's so significant about that day?

Jesus was born on Rosh Hashanah of 2 B.C. Exactly two thousand years later, Rosh Hashanah of 1999 (the first day of the Hebrew year 5760) would have been His 2000th birthday. Rosh Hashanah of A.D. 1999 saw the ending of man's 6,000-year dominion of earth. At that point in time Jesus holds the open scroll, the right of rulership. The date was September 11, 1999.

On September 11, 2001, the icons of man's greatness of world power – the twin towers of the World Trade Center – fell and became rubble that was bulldozed away. The message is clear: on September 11, 1999 man's allotted time of rulership expired; and on September 11, 2001, that which represented the power and strength of man's rulership, fell

and became rubble. The portends are clear. The overthrow of man's governments will follow.

> *"The great day of the Lord is near ... the mighty man shall cry there bitterly ... that day is a day of wrath ... a day of the trumpet and alarm ... <u>against the high towers</u> ... neither their silver nor their gold* (stolen from Jericho) *shall be able to deliver them in the day of the Lord's wrath."* (Zephaniah 1:14-18)

But *"He whose right it is"* will establish a divine government of peace and prosperity. Then *"Babylon, the glory of the kingdoms, the beauty of the Chaldean excellence* (represented by the gold), *shall be as when God overthrew Sodom and Gomorrah,"* (Isaiah 13:19). Then Isaiah adds: *"It shall not be inhabited forever."*

It shall not be inhabited forever

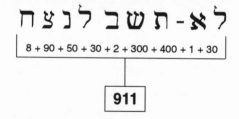

The date 9-11 is vividly imbedded in the minds of the people of the world – the day the icons of world power fell.

In fact, the event has come to be known as "911," and the place as "ground zero."

The number 911 is an interesting number in the Gematria of the scriptures. Just as the number 8 is the number of New Beginning, so the number 911 carries a similar thought, but is extended to imply the work that will be accomplished at that New Beginning.

8 = Beginning, אז
8 = Entry, באה
8 = He who comes, הבא
8 = Save, η
911 = Beginning, ראשית
911 = First (or firstfruit), ראשית
911 = Present (to make a gift), תשורה
911 = It shall not be inhabited forever, לא-תשב לנצח

It appears that 911 indicates a time of new beginning, reaping the fruit of what has gone before, and destroying the remainder of the old. And surely *"He who comes"* – 8 – came into legal right of rulership on 9-11 of the year A.D. 1999. The icons of that which will be destroyed fell on 9-11 of A.D. 2001.

September 11, 1999 was the first day of the Hebrew year 5760. It marks the beginning of an era. Jesus is not only the process of the overthrowing the old Jericho, which

had the stench of death; He is also the One *"standing in the breach"* on behalf of the new Jericho, *"city of the moon."* The numbers tell the story.

Moon (new moon)

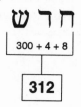

חד ש

| 300 + 4 + 8 |

312

576 + 312 = 888

His chosen one
stood in the breach before him.

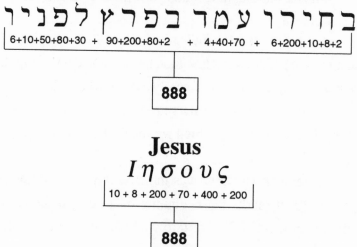

בחירו עמד בפרץ לפניו

| 6+10+50+80+30 + 90+200+80+2 + 4+40+70 + 6+200+10+8+2 |

888

Jesus
Ιησους

| 10 + 8 + 200 + 70 + 400 + 200 |

888

Jesus, as earth's rightful possessor of the throne, will *"stand in the breach"* as mediator between God and man. The Apostle Paul understood this and explained it to Timothy.

> *"...who will have all men to be saved, and to come unto the knowledge of the truth. For there is one God, and one mediator between God and men, the man Christ Jesus."* (Timothy 2:4-5)

The Gematria leaves no doubt as to whom Paul was referring:

Mediator between God and men
μεσιτης θεου και ανθρωπων

40+5+200+10+300+8+200+9+5+70+400+20+1+10+1+50+9+100+800+80+800+50

3168

Lord Jesus Christ
Κυριος Ιησους Χριστος

20+400+100+10+70+200+10+8+200+70+400+200+600+100+10+200+300+70+200

3168

The prophet Isaiah, after describing the transition of rulership, exclaims:

> *"There shall be a tabernacle (booth) for a shadow in the daytime, and for a place of refuge, and for a covert from the storm and from rain."* (Isaiah 4:6)

It will be the age of Tabernacles. The age is described as the light of seven moons shining <u>as</u> the sun.

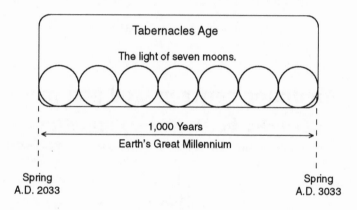

Tabernacles was a seven day festival, in which the people left their homes and lived in "booths." It was a very joyous occasion, with music, dancing, drawing of water, the lighting of lamps, and the sharing of food. It was sometimes called "the feast of ingathering" because it followed the grape harvest.

Isaiah described the Tabernacles Age and used terminology that is descriptive of the celebration of the joy of the

Feast of Tabernacles.

> *"And in this mountain* (Christ's Kingdom) *shall the Lord of hosts make unto all people a feast of fat things, a feast of wines on the lees, of fat things full of marrow, of wines on the lees well refined. And he will destroy in this mountain the face of the covering* (death) *cast over all people, and the vail that is spread over all nations* (He will heal the nations with peace and prosperity). *He will swallow up death in victory; and the Lord God will wipe away tears from off all faces; and the rebuke of his people shall he take away from off all the earth."* (Isaiah 25:6-8)

By the time the seven days of Tabernacles comes to a close, these will be the conditions in the earth. This is the purpose of the Tabernacles Age: to bring man back to all that he lost in Adam.

Tabernacles was the third, and last, of the pilgrim festivals. All the males were to present themselves, with a gift, to God at the temple. It pictures all mankind, by the end of the Millennium, having presented themselves, with the gift of their heart, to God. It is the time of the healing of all mankind from the oppression and sin of man's rulership, and giving them in return the blessings of freedom and righteousness of divine government.

This healing of the nations was pictured by the healing of the captain of the army of Syria – a Gentile by the name of Naaman.

Naaman had leprosy – a picture of sin. It was suggested to him, by a young Israelite girl, that he go to Israel to be healed of his leprosy. When Naaman went to Israel to be healed, he offered the king of Israel gold, silver and royal garments. (Wasn't this what Achan had stolen from old Jericho and buried in the earth?)

Naaman went to the house of Elisha, and was instructed to go down to the Jordan river and wash seven times. Naaman was not too keen on the idea at first, but after raising his objections to the idea, he finally went down to the Jordan, by Jericho, and washed seven times.

> *"Then went he down, and dipped himself seven times in Jordan, according to the saying of the man of God; and his flesh came again like unto the flesh of a child, and he was clean."* (II Kings 5:14)

After Naaman (who pictured the Gentile rulership of earth) washed in the Jordan seven times (corresponding to the seven moons and seven days of Tabernacles), his leprosy was gone and he was restored to health. Then he became converted.

> *"And he returned to the man of God* (Elisha),

he and all his company, and came, and stood before him, and he said, Behold, now I know that there is no God in all the earth, but in Israel." (II Kings 5:15)

He then loaded up two mules with soil from Israel, to take back to his home.

Naaman, spelled in Hebrew, נעמן, adds to 210 and multiplies to 7 (dropping the zeros). Both numbers relate to the seven moons that shine as the sun. The *"seven times"* that he washed in Jordan illustrates the full length of the Tabernacles Age. It was a seven day festival. But there is even more evidence when we look at the Gematria. *"Seven times"* as used in this text, is from the Hebrew words שבע פעמים, which adds to 612. It is the same number value as "covenant," (*brit,* ברית) as is used throughout the Hebrew scriptures.

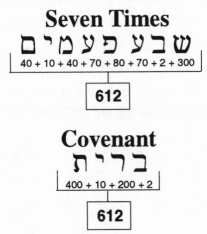

Seven Times

ש ב ע פ ע מ י ם

40 + 10 + 40 + 70 + 80 + 70 + 2 + 300

612

Covenant

ב ר י ת

400 + 10 + 200 + 2

612

The nations of earth (pictured by Naaman) have leprosy (sin). But by washing seven times they enter into the covenant of which Jesus is the Mediator. By washing in the Jordan at new Jericho, "the city of the moon," they "seven themselves" – at least this will be true of those nations who are willing to give up the stolen gold, silver and Babylonian robes.

> *"And it shall come to pass, that every one*
> *that is left of all the nations which came*
> *against Jerusalem shall even go up from year*
> *to year to worship the King, the Lord of hosts,*
> *and to keep the feast if Tabernacles."*
> (Zechariah 14:16)

The numbers involved here are nothing short of magnificent!

Earth's Great Millennium, the day when the light of seven moons shines as the sun, is the seventh 1,000-year "day" of man's "week" of time. It is also called the "third day" in many prophecies. Thus the numbers 3 and 7 represent the same work, *i.e.,* the time of resurrection (3) and the time of perfecting and completing (7).

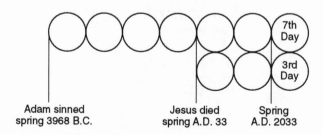

Adam sinned	Jesus died	Spring
spring 3968 B.C.	spring A.D. 33	A.D. 2033

The third day from the death of Jesus is the seventh day from the sin of Adam. And the numbers 3 and 7 are the factors of 21 – three octaves minus its final note of conclusion.

Three octaves = 21 notes
3 and 7 are factors of 21
7 moons of 30 days = 210 days
Naaman = 210 (by addition)
Naaman = 7 (by multiplication)

Naaman, a man of war, whose numbers are 210 and 7, went to the king of Israel and gave him gold, silver, and garments. Then he washed in the Jordan at Jericho seven times and his leprosy was healed, and he became a believer and confessed that the God of Israel was the one and only true God.

Naaman (210 & 7) pictures the nations of earth (men of war) who give back the stolen gold, silver, and Babylonian robe, and wash seven times (during the age of the seven

days of Tabernacles). But the amount of gold, silver and garments that Naaman gave back far exceeded the amount that had been stolen.

Achan had stolen 50 shekels of gold, 200 shekels of silver, and one Babylonian robe (from Shinar). It was a very small amount when compared to the gold, silver and garments that Naaman gave to the king of Israel. The King James Version reads:

> *"And he departed, and took with him ten talents of silver, and six thousand pieces of gold, and ten changes of raiment."*

The word "pieces" has been supplied by the translators. The Masoretic Text reads:

> *"And he went and took in his hand ten talents of silver, and six thousand of gold, and ten changes of garments."*

The unit of weight for the gold is not stated. Obviously the translators of the King James Version were aware that if the unit for the gold was also a talent, then they would be dealing with 450,000 pounds of gold, which is not a likely amount that they would be carring either by horseback or by chariot. Thus they simply supplied the word "pieces," leaving it an unspecified weight. We do not know for sure what the weight unit was, but let me suggest it may have been a shekel. If so, then it would be a more reasonable weight of

150 pounds of gold, which could easily have been carried on a pack horse, along with the 75 pounds of silver.

If this is a reasonable assumption, then the numbers become very significant. The ten talents of silver are equal to 30,000 shekels. Thus the amount that Naaman (the nations of the world) gives back is:

> 6,000 shekels of gold
>
> 30,000 shekels of silver
>
> 10 garments

The amount that Achan had stolen was 50 shekels of gold, 200 shekels of silver and 1 robe. Thus that which is given back becomes:

> 120 times more gold
>
> 150 times more silver
>
> 10 times more garments

The number 10 represents man's responsibility to God; the number 15 is the Gematria for "power"; and 12 is the number for divine government. It very beautifully shows the final willingness of the nations to enter into divine government.

After this, they will wash seven times and be healed from the leprosy of sin. They will "seven themselves" – enter into the covenant.

God had "sevened himself" on Mount Moriah and said:

> *"By myself have I sworn* (sevened myself)
> *for because thou hast done this thing, and
> hast not withheld thy son, thine only son: that
> in blessing I will bless thee, and in multiply-
> ing I will multiply thy seed as the stars of
> heaven, and as the sand which is upon the
> seashore, and thy seed shall possess the gate
> of his enemies; and in thy seed* (Isaac–Jesus)
> *shall all the nations* (peoples) *of the earth be
> blessed."* (Genesis 22:16-18)

Thus on the third day, which is also the seventh day, the healing and blessing of the nations will come, to those who give back the stolen *"devoted thing."*

When Joshua identified the one who had stolen the *"devoted thing,"* he took him out into a valley (עמק = 210) and had him stoned to death and buried there.

> *"Wherefore the name of that place was called
> the Valley of Achor."* (Joshua 7:26)

But there is hope for those buried in the Valley of Achor (Valley of Grief).

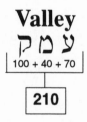

Valley

עמק

100 + 40 + 70

210

The hope is in the sevenfold light of the moon that shines as the sun. The new moons were for the counting of months. Seven of them would be 210 days (7 x 30). Thus Naaman (210 & 7) will be healed by washing seven times in the Jordan. The 210 (drop the zero) is 21, which is the number 12 reading from right to left. It is through 12 (divine government) that the healing is accomplished.

The prophet Hosea spoke of a time when the Valley of Achor would be a "door of hope." A door is for the purpose of walking through to get to another place. Thus it is out from the Valley (210) of Achor that hope can be realized. The literal translation from the Masoretic Text reads:

> *"And I will give to her her vineyards from there, and the valley of Achor for an entrance of hope."* (Hosea 2:15)

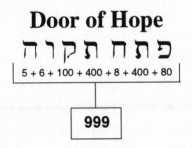

Door of Hope

פתח תקוה

5 + 6 + 100 + 400 + 8 + 400 + 80

999

The number 9 represents perfection, completion, fulfillment and finality. This is where the Door of Hope leads. The number 999 identifies God in the beginning and in the

completion of His work with man.

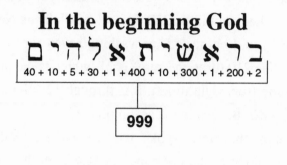

In the beginning God

בראשית אלהים

40 + 10 + 5 + 30 + 1 + 400 + 10 + 300 + 1 + 200 + 2

999

Glory of God

$\delta o \xi \alpha v \ \Theta \varepsilon \omega$

4 + 70 + 60 + 1 + 50 + 9 + 5 + 800

999

The numbers 9, 12 and 21 tell a magnificent story. In Gematria, zeros are merely place holders, and can be dropped, thus 210 is the same as 21. We are considering 21 and its mirror opposite, 12. The 21 is the means-by-which, and the 12 is the accomplishment. And in this case, the accomplishment is divine government, which is represented by the number 12. The number 21 is the process of fully accomplishing divine government – 12.

Day 7
Day 3

1,000 Years
Tabernacles Age

8

The perod of time during which this process is in progress is represented by the seven-fold shining of the moon.

> *"The light of the moon shall be as the light*
> *of the sun, and the light of the sun shall be*
> *sevenfold, as the light of seven days, in the*
> *day that the Lord bindeth up the breach of*
> *his people, and healeth the stroke of their*
> *wound."* (Isaiah 30:26)

The method of counting months was by the occurrence of the new moon. The word "month," or "moon," in Hebrew is חדש. This word also means to "renew." It has the number value of 312.

The age of renewal – the Tabernacles Age – is thus represented by the numbers 21 and 312. Put them together and we have the most beautiful palindrome in the whole science of Biblical Gematria, for it describes the accomplishment, completion, finality and fulfillment of the whole plan of God for the salvation of man. This number in all its glory

and beauty will be the subject of the next chapter.

21312
2 x 1 x 3 x 1 x 2 = 9
2 + 1 + 3 + 1 + 2 = 12

"The palaces (seats of man's rulership) *shall be forsaken; the multitude of the city* (man's governments) *shall be left; the forts* (strongholds) *and towers* (world power) *shall be for dens for ever, a joy of wild asses, a pasture of flocks; until the spirit be poured upon us from on high, and the wilderness be a fruitful field, and the fruitful field be counted for a forest. Then judgment shall dwell in the wilderness, and righteousness remain in the fruitful field. And the work of righteousness shall be peace; and the effect of righteousness quietness and assurance for ever. And my people shall dwell in a peaceable habitation, and in sure dwellings, and in quiet resting places."* (Isaiah 32:14-18)

10

No More Sevens

In chapter one we began by noting the fact that the book of Revelation tells of 22 groups of sevens, making three complete octaves, including the final note of conclusion. They are:

1. Seven churches
2. Seven golden candlesticks
3. Seven stars
4. Seven angels
5. Seven lamps of fire
6. Seven spirits
7. Seven seals
8. Seven horns
9. Seven eyes
10. Seven more spirits
11. Seven things Lamb receives
12. Seven more angels
13. Seven trumpets
14. Seven thunders
15. Seven heads
16. Seven crowns
17. Seven more heads
18. Seven more angels
19. Seven bowls of wrath
20. Seven plagues
21. Seven mountains
22. Seven kings

Beyond this there are no more sevens – only a profusion of twelves.

The number seven relates to the making of a covenant, a sworn oath. The Hebrew word for "swear" is the same word used for "seven." Its relationship to a covenant is in its Gematria as well.

612 = Seven times, שבע פעמים
612 = Covenant, ברית

But "seven times" and "covenant" also carry within them the eventuality of 12 and 9 (divine government and finality).

$$6 \times 1 \times 2 = 12$$
$$6 + 1 + 2 = 9$$

The beautiful palindrome that represents the Tabernacles Age has its eventuality in the same 12 and 9.

$$21312$$
$$2 \times 1 \times 3 \times 1 \times 2 = 12$$
$$2 + 1 + 3 + 1 + 2 = 9$$

By the end of the Tabernacles Age, divine government, represented by 12, will be fully established in the earth. However, man's governments, in the book of Revelation, are represented by the number 10 – "ten horns," "ten kings," "ten crowns."

Originally, when dominion was given to Adam in the Garden of Eden, his acceptable rulership was dependent upon his responsibility to God. That responsibility to God was represented by the number 10. He defiled that responsibility. Yet, responsibility to God is still a valid requirement for acceptable rulership. Thus the number 10 includes both.

Because of Adam's disobedience, *"death reigned from Adam to Moses."* It was a period of 2,520 years during which a way to return to obedience was not provided. Then at the end of 2,520 years, God instructed Moses to select a lamb, without blemish, on the 10th day of Abib (Nisan). Four days later they killed the lamb and sprinkled its blood on the doorframes of their houses, to save the firstborn of each household from death that night. It pictured Jesus, 4,000 years ("days") after Adam's sin, pouring out His innocent blood to save Adam and his household – all mankind.

Fifty-two days after that night of the first Passover, Moses was called up to the top of Mount Horeb to receive the Law of God – the Ten Commandments. Those ten fundamental laws were, in fact, man's responsibility to God. And they still are! They are fundamental to experiencing a

relationship with God. These 10 fundamental Laws of God (the Decalogue), will be the foundation principles of divine government as will be established by the New Jerusalem.

The relationship of the Ten Commandments to the New Jerusalem is awesome! Not only in that it is the basic fundamental laws of the New Jerusalem, but the relationship of its Gematria is positively marvelous.

In an attempt to obtain the original text of the Ten Commandments it is good to refer to the text as written in the Targum of Onkelos. The work of Onkelos was specifically with the five books of Moses, and particulary with the Decalogue. He was an expert. He sought for the purity of the text, as it had originally been given to Moses. In doing so, he made two very minor changes, which do not change the meaning of the text, but it does change the Gematria. If the work of Onkelos has brought us back to the original text as it was given to Moses, then we could expect it would render the Gematria accurate and meaningful. (Please see *The Bible in Aramaic, The Pentateuch According to Targum Onkelos,* by Alexander Sperber.)

One of those changes occurs in the first Commandment. *"You shall have no other gods before me."* In the Masoretic Text the word "gods" is אלהים (Elohim), a plural word. Onkelos renders this word אלה (Eloh), a singular word. Thus the English translation would be *"You shall have no other god before me."* The meaning is the same, but by drop-

ping the דם from the text, it reduces the Gematria by 50.

The second change is in the fourth Commandment. *"Remember the Sabbath day by keeping it holy."* The minor change that Onkelos records is simply the dropping of the Hebrew letter ה from the word "Sabbath." Putting this letter on the word "Sabbath" is called an attachment. The letter ה when attached to the beginning of a word is the definite article "the." Thus Onkelos has rendered this as "Sabbath" whereas the Masoretic Text renders it "the Sabbath." The definite article has already been given its place in the sentence as it is written in Hebrew; thus attaching one to the word Sabbath is redundant. By dropping this extra ה it reduces the Gematria by 5.

Thus, the two minor changes which Onkelos recorded, in an effort to be pure to the original text as was given to Moses, will reduce the Gematria of the Ten Commandments by 55.

These two minor changes do not alter the meaning of the text. but rather they render it more gramatically correct, both in English and in Hebrew. Because Onkelos was considered an expert on the books of Moses, and especially of the Ten Commandments, we can have a large measure of confidence in the accuracy of his text.

Let's look at the text of the Ten Commandments by Onkelos, and observe its remarkable Gematria.

The Ten Commandments

1, You shall have no other god before me.
לא־יהיה־לך אלה אחרן על־פני
140 100 259 36 50 30 31 ..646

2. You shall not make for yourself an idol in the form of anything in heaven above or on the earth beneath or in the waters below. You shall not bow down to them or worship them.
לא תעשה־לך פסל וכל־תמונה אשר בשמים ממעל ואשר בארץ
293 507 180 392 501 501 56 170 50 775 31
מתחת ואשר במים מתחת לארץ לא־תשתחוה להם ולא תעבדם
516 37 75 1119 31 321 848 92 507 8487850

3. You shall not misuse the name of the LORD your God.
לא תשא את־שם־יהוה אלהיך לשוא
337 66 26 340 401 701 31..1902

4. Remember the Sabbath day by keeping it holy.
זכור את־יום שבת לקדשו
440 702 56 401 233..1832

5. Honour your father and your mother.
כבר את־אביך ואת־אמך
61 407 33 401 26 ..928

6. You shall not murder.
לא תרצח
698 31 ..729

7. You shall not commit adultery.
לא תנאף
531 31 ..562

8. You shall not steal.
לא תגנב
455 31 ..486

9. You shall not give false testimony against your neighbor.
לא־תענה ברעך עד שקר
600 74 292 525 31 ..1522

10. You shall not covet your neighbour's house. You shall not covet your neighbour's wife, or his manservant or maidservant, his ox or donkey, or anything that belongs to your neighbor.
לא תחמר בית רעך לא־תחמר אשת רעך ועבדו ואמתו
453 88 290 701 452 31 290 412 452 31
ושורו וחמרו וכל אשר לרעך
320 501 56 260 518 ..4855

21312

The total Gematria for the Ten Commandments is 21312. In Gematria it is observed that palindromes appear to be universal in scope. And surely this palindrome has that appearance. This number, 21312, is basic to man's responsibility to God, which ultimately brings relationship with God.

If we divide 21312 by the ultimate number 9, we get the means whereby that relationship with God can be possible. It is through Jesus Christ.

$$21312 \div 9 = 2368$$

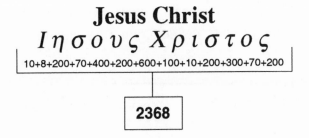

Jesus Christ
Ιησους Χριστος

10+8+200+70+400+200+600+100+10+200+300+70+200

2368

The number 21312 is the Ten Commandments – the Law. Jesus is the fulfillment of the Law and all that it promised for man. He is not only the fulfillment of the Law, but He also completes the whole purpose of the Law. He is completion and fulfillment. He is all that is involved in the number 9. Thus 9 x 2368 = 21312.

Jesus' connection to the Law and the number 21312 is

also shown by another method. The Gematria for the word "commandments" in Hebrew is 240.

$$24 \times 888 = 21312$$

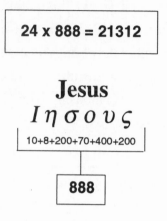

Jesus

$I\,\eta\,\sigma\,o\,\upsilon\,\varsigma$

10+8+200+70+400+200

888

The Ten Commandments contain 239 Hebrew letters. This is 34 full octaves, including the final note of conclusion.

$$7 \times 34 = 238 \text{ (plus the note of conclusion)}$$

If these 34 octaves were taken as Jubilee cycles, it would give a year-count of 1,666, ($34 \times 49 = 1666$). The number relates precisely to the New Jerusalem. But what has the New Jerusalem to do with the Ten Commandments? It has everything to do with it!

1666 = The Holy City the New Jerusalem

Beginning with chapter 19 of the Apocalypse, we find no more sevens – only a beautiful array of twelves. The description of the New Jerusalem is replete with twelves. It is a description of the completed divine government that will engulf the whole earth with its peace, its justice, and its joy.

The Ten Commandments are man's basic responsibility to God. The keeping and fulfilling of them brings relationship to God. This will be the happy condition of all of Adam's race by the end of the Millennium, when divine government, the New Jerusalem, will cover the earth.

The New Jerusalem is described as having 12 gates, bearing the names of the 12 tribes of Israel, and 12 foundation gemstones, inscribed with the names of the 12 apostles. This array of twelves is most impressive. Let's take the names of the twelve tribes of Israel, as they are listed in Revelation 7, and exactly as they are spelled in Thayer's Greek Lexicon. When we compute their total, we find they add to 8880. They bear the name of their Messiah, Jesus. But in Revelation 7 it is said that there were to be 12,000 from each tribe. If we multiply the 8880 by 12,000, dropping the extra zeros, it produces the amazing number 10656. When we also list the names of the twelve apostles, exactly as they are spelled in Thayer's Greek Lexicon, and add their total, we get the same number, 10656. Thus these two magnificent numbers, when combined, produce a total of 21312 – the

total Gematria of the Ten Commandments.

$$10656 + 10656 = 21312$$

The wall, with its twelve gates, bearing the names of the twelve tribes of Israel, and the foundation gemstones, inscribed with the names of the twelve apostles, bear the same number as the total Gematria of the Ten Commandments. It is no mere coincidence. They are not random numbers. They were placed there by the hand of the Master Mathematician.

The Ten Commandments are man's responsibility to God. And the New Jerusalem, divine government, is man's relationship to God. Responsibility, when kept, brings relationship.

Peter	*Πετρος*	755
Andrew	*Ανδρεας*	361
James	*Ιακωβος*	1103
John	*Ιωαννης*	1119
Phillip	*Φιλιππος*	980
Nathanael	*Ναθαναηλ*	150
Levi (Matthew)	*Λευι*	445
Thomas	*Θωμας*	1050
James (son of Alpheus)	*Ιακωβος Αλφαιου*	2115
Lebbaeus (Thaddeus)	*Λεββαιος*	320
Simon the Canaanite	*Σιμων ο Κανανιος*	1573
Judas	*Ιουδας*	685
		10656

```
Judah ................... Ιουδα ................................. 485
Reuben ............... Ρουβην ............................. 630
Gad ...................... Γαδ ....................................   8
Asher ................... Ασηρ ................................. 309
Nepthalim ........... Νεφθαλειμ ........................ 650
Manassas ........... Μανασσης ........................ 700
Simeon ............... Συμεων ............................ 1495
Levi ...................... Λευι .................................... 445
Issachar .............. Ισσαχαρ ........................... 1112
Zebulon .............. Ζαβουλων ........................ 1360
Joseph ................. Ιωσηφ ............................... 1518
Benjamin ............ Βενιαμιν ........................... 168
                                                        ─────
                                                         8880

8880 x 12,000 from each tribe = 10656 (dropping zeros)
```

There is no way that the beautiful correspondence of these numbers could be the result of randomness or coincidence. They furnish evidence, and give us confidence, that the numbers were part of the original design of the Creator.

To the faithful "Church of Philadelphia" John wrote:

> *"I will write on him the name of my God,
> and the name of the city of my God, which is
> the New Jerusalem, which cometh down out
> of heaven from my God: and I will write on
> him my new name."* (Revelation 3:12)

John may not have realized that the Gematria of what he was writing confirmed the numbers that define the New Jerusalem.

> **10656 = I will write on him the name of my God, and the name of the city of my God, the New Jerusalem.**

After John saw the vision of the New Jerusalem, he described it in language that is hard for us to comprehend, because it describes conditions with which we have had no experience. He was describing conditions that will exist at the end of Earth's Great Millennium, when the righteous laws of the Kingdom will have been fully established in the earth. This is the Kingdom that Jesus will turn over to the Father, that God may be *"all in all."* Yes, Jesus has this right, because He holds the open scroll. He has the legal right of rulership. And when all mankind are brought into that Kingdom, He presents it to the Father.

> *"Then cometh the end* (end of the Millennium) *when he shall have delivered up the kingdom to God, even the Father ... for he must reign till he hath put all enemies under his feet ... the last enemy that shall be destroyed is death ... and when all things shall be subdued unto him, then shall the Son also himself be subject unto him that put all things under him, that God may be all in all."*
> (I Corinthians 15:24-28)

John described this completed Kingdom:

> *"And I saw a new heaven and a new earth*
> (now completely under the administration of
> righteousness) ... *And I saw the New Jerusa-*
> *lem, coming down from God out of heaven*
> *... And I heard a great voice out of heaven*
> *saying, Behold, the tabernacle* (dwelling
> place) *of God is with men, and he will dwell*
> *with them, and they shall be his people, and*
> *God himself shall be with them, and be their*
> *God. And God shall wipe away all tears from*
> *their eyes; and there shall be no more death,*
> *neither sorrow, nor crying, neither shall there*
> *be any more pain; for the former things are*
> *passed away."* (Revelation 21:1-4)

The beautiful palindrome of the principles of God's Law
will bring mankind back into the relationship with God that
Adam had in the Garden of Eden before he sinned. And it
brings into existence another palindrome – one involving
the number 144.

In ancient Israel, they had a word for "truth" which was
an acronym for "God the Eternal King, in the infinite past
present and future" – the word was *emet,* אמת, which has a
number value of 441. But when describing the fact that God
was from "everlasting to everlasting" having no beginning

nor ending, they used the word *kedem*, קדם, which has a number value of 144. Put them together and we have the palindrome 144441. Whether we add or multiply the digits in this palindrome we produce numbers that are basic to the existence of God.

$$1 + 4 + 4 + 4 + 4 + 1 = 18$$
$$1 \times 4 \times 4 \times 4 \times 4 \times 1 = 256$$

When we find the numbers 1 and 8 together we always know it refers to the Beginning and the New Beginning, and, of course to the Beginner and the New Beginner.

Just as the word *emet*, אמת, "truth," bears the number 441, so the word "truth" in Greek bears the number 256. It is part of the design of the Master Mathematician. Below are some of the occurrences of 256 in the Gematria of the scriptures. It also carries the thought of a Beginner and a New Beginner.

256 = Truth, αληθης
256 = Holiness, αγασμα
256 = Commandments (the ten), דברים
256 = Thy Kingdom is and everlasting Kingdom and thy
 dominion throughout all generations (Psalms 145:13)

Thus we have two magnificent palindromes that give us the whole concept of the Creator, His requirement for relationship with Him, and the ultimate fulfillment of it in the everlasting Kingdom which He has planned and prepared for man.

21312
2 + 1 + 3 + 1 + 2 = 9
2 x 1 x 3 x 1 x 2 = 12

144441
1 + 4 + 4 + 4 + 4 + 1 = 18
1 x 4 x 4 x 4 x 4 x 1 = 256

This amazing number, that defines the Law of God and the foundation and wall of the New Jerusalem – 21312 – is a beautiful multiple of 12. After the sevens come to fruition, and fulfillment, the number twelve continues. Divide the number 21312 by 12 and it produces 1776. It is a number full of meaning. It defines the New Jerusalem and the King who brought it to its fullness.

1776 = And they shall call you the City of Jehovah, the Zion of the Holy One of Israel. (Isaiah 60:14)

A promise was given to Israel for obedience to the Law. It was part of the Mezuzah – the little scroll that they were to nail to their doorposts, and wear as an amulet around the neck.

> *"Thou shalt write them upon the door posts of thine house, and upon thy gates: that your days may be multiplied, and the days of your children, in the land which the Lord sware* (sevened) *unto your fathers to give them, as the days of heaven upon the earth."* (Deuteronomy 11:21)

Reading this from the Masoretic Text we find:

1776 = To give to them as the days of the heavens on earth.

The *"days of the heavens on earth"* describes the time when the New Jerusalem comes down from God out of heaven and engulfs the whole earth, fulfilling all that has been promised.

The New Jerusalem will fully come into fulfillment when the resurrection work is complete, and mankind again has life – the life that Adam lost. And we find the number 1776 defining that resurrection and life.

<div style="border: 1px solid black; padding: 10px;">

1776 = Resurrection, life, $\alpha \nu \alpha \sigma \tau \alpha \sigma \iota \varsigma \ \zeta \omega \eta$
(John 11:25)

</div>

John saw in vision, a river flowing out from the throne of God, very similar to the vision that Ezekiel had, where he saw a stream coming out from under the temple, which grew in size and depth until it completely healed the waters of the Dead Sea, and gave it life. It illustrates the life-giving truth that will flow to mankind from the divine administration of righteous government.

<div style="border: 1px solid black; padding: 10px;">

1776 = River of life, $\pi o \tau \alpha \mu o \varsigma \ \zeta \omega \eta \varsigma$,
(Revelation 22:1)

</div>

10608 = And he showed me a pure river of water of life, clear as crystal, proceeding out of the throne of God and of the Lamb. (Revelation 22:1)

1680 = Christ, $X \rho \iota \sigma \tau o \upsilon$

186 = And there shall be no more curse. (Revelation 22:3)

816 = His dominion

618 = The Lord shall be king over all the earth. (Zechariah 14:9)

186 = The day of conclusion (8th day of Feast of Tabernacles.)

After showing John the vision of the New Jerusalem, Jesus identified himself as the One who would bring it into completion. He said:

> *"I, Jesus, have sent mine angel to testify unto you these things in the churches. I am the root and the offspring of David, the bright and morning star."* (Revelation 22:16)

1776 = I am the root and offspring of David,
εγω ειμι η ριζα και γενος Δαυιδ

Jesus called himself the *"Lord of the Sabbath."* It is a title that suggests He will be the Lord, the ruler, during the great Sabbath day, the Millennium, which is the seventh day from the disobedience of Adam.

1776 = Lord of the Sabbath, *Κυριος σαββατου,*
(Mark 2:28)

This evidence from the number code is profound. The number that defines the very foundations of the New Jerusalem, 21312, when divided by the number for divine government, 12, produces the amazing number 1776. They are not random numbers. They are the work of One who has planned for eternity. It is a plan for the ultimate joy of all mankind.

This new divine government supplants the sinful, leprous governments of man. The gold and the silver and the Babylonian garments are finally given over into the treasury of the Lord, and the nations can be healed by the sevenfold washing during the seven days of the Tabernacles Age, until sevens are all fulfilled – only the twelves of the New Jerusalem remain.

In chapter 5 was shown the distance that light travels in all directions out from the sun in one year. It would form a sphere of light 11.731392 trillion miles in diameter. Across this diameter would fit 1,480 billion earths, just touching at the equator. That is a sphere of one year of light. Let's multiply by the 12 that represents divine government. This would form a sphere of light that would take 12 years to produce. Now if we attempted to place a quantity of earths side by side across the diameter of this incomprehensibly huge sphere, we would find it would take 17,760 billion earths to reach its distance. It becomes apparent that the number 1776 was part of the Master Plan that was put into motion long before man was created upon this earth. The means whereby the ultimate divine government could become a fulfilled reality was planted in the speed of light.

This is probably why the vision that John saw used the "sign" of light from God, even supplanting the light of the sun, to convey to us the idea that His kingdom will be universal in scope and divine in power and authority.

"The city had no need of the sun, neither of the moon, to shine in it: for the glory of God did lighten it, and the Lamb is the light thereof." (Revelation 21:23)

In chapter 21 of Revelation, John described the New Jerusalem as being a cube, with sides of 12,000 furlongs and a wall of 144 cubits. When converted to British measures, it becomes apparent that the dimensions of the New Jerusalem exactly parallel those of the earth, but in feet instead of miles.

Earth
Diameter 7,920 miles
Perimeter of square 31,680 miles
Lord Jesus Christ = 3168

New Jerusalem
Diameter of wall
7,920,000 feet
792 = Lord Jesus Christ

Perimeter of square
31,680,000 feet
3168 = Lord Jesus Christ

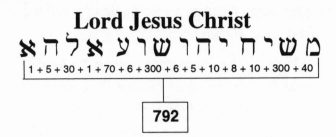

Lord Jesus Christ

מ ש י ח י ה ו ש ו ע א ל ה א

1 + 5 + 30 + 1 + 70 + 6 + 300 + 6 + 5 + 10 + 8 + 10 + 300 + 40

792

Lord Jesus Christ

Κ υ ρ ι ο ς Ι η σ ο υ ς Χ ρ ι σ τ ο ς

20+400+100+10+70+200+10+8+200+70+400+200+600+100+10+200+300+70+200

3168

There is no possible way that these number relationships could have been fabricated by man. They are beyond the scope of man's ability. They provide a magnificent demonstration of the detailed planning of the Creator. Long before the New Jerusalem would come into being, He designed the size of the earth to correspond to its measures precisely, and He planned the Gematria to give a witness of the One who would purchase mankind out of the condemnation from sin, and deliver them into a glorious divine government of peace and righteousness.

Long before John saw the vision of the New Jerusalem,

the prophet Isaiah received a description of it and recorded it for our delight. He wrote:

> *"Violence shall no more be heard in thy land, wasting nor destruction within thy borders; but thou shalt call thy walls Savation, and thy gates Praise. The sun shall be no more thy light by day; neither for brightness shall the moon give light unto thee: but the Lord shall be unto thee an everlasting light, and thy God thy glory. Thy sun shall no more go down; neither shall thy moon withdraw itself; for the Lord shall be thine everlasting light, and the days of thy mourning shall be ended. Thy people also shall be all righteous: they shall inherit the land for ever, the branch of my planting, the work of my hands, that I may be glorified."* (Isaiah 60:18--21)

11

The Music of the Ages

The apparent change from sevens to twelves was planted in the vibration that we call music, and beautifully traces the story of creation and of man, converting from seven to twelve at the transition from Earth's Great Millennium into the Great Eighth Day, the note of conclusion, which begins God's Grand Jubilee.

In Genesis 1:2 we are told, *"The spirit of God moved upon the face of the waters."* This statement is followed by the scale of seven notes, or epochs of creation, the seventh of which is man's day, and God's sabbath of rest. The word "moved" hardly conveys the true meaning of the Hebrew word *rachaph,* רחף, which is used here. This word is used only three times in the entire Bible, and is translated:

Genesis 1:2 *"moved"*
Deuteronomy 32:11 *"fluttered"*
Jeremiah 23:9 *"shake"*

The fundamental meaning of the word is to "vibrate." Gesenius' Hebrew Lexicon suggests the added connotation of an eagle "brooding" or "trembling" over her young.

This word *rachaph*, רחף, adds to 288 and multiplies to 128. These two numbers appear to have great significance in relation to the sevenfold counting of the ages and the transition into the full establishment of the New Jerusalem, when it comes down and engulfs the earth. Notice how apparent is the connection between 288 and the New Jerusalem.

2880 = Kingdom of heaven, βασιλεια των ουρανων, (Matthew 18:47)

288 = A Tabernacle that shall not be taken down (The New Jerusalem), אהל בל יצען, (Isaiah 33:20)

288 = The joy of the Lord, την χαραν του Κυριου, (Matthew 25:21)

There is also a connection with the Bride, who is with Jesus – married to Him – during the process of establishing the righteous government of the New Jerusalem, and to His office of both King and Priest.

2880 = The Bride, the Lamb's wife, την νυμφην την γυναικα αρνιου, (Revelation 21:9)

288 = Betrothed, חרף

288 = He shall be a priest on his throne, והיה כהן על כסאו, (Zechariah 6:13)

Thus the word *rachaph*, bearing the number 288 and

having the meaning of "to vibrate," appears to relate to the scale of music vibration, counting off the time to the transition into the Great 8th Day, the note of conclusion.

Music is a matter of vibration. Those vibrations enter our ears and are sent to the brain where they are translated into sounds. All sound is vibration, but music is a special arrangement of vibration that follows specific mathematical progression. The result is harmony. It is comfortable to our very core. It is soothing and healing to both the mind and body. The old saying that "Music hath charm to soothe the savage breast" is a true-ism. And its opposite, cacophony, can actually make us ill.

The sounds that are harmonious to the human ear are based in the number 7. However, we think in terms of 8, the octave, which in reality is 7 plus a new beginning. The progression of the octave was not the invention of man. It occurs naturally as the first and second partials of sounds usually considered to be musical.

The laws of musical harmony were not invented by man; they were discovered. Those laws reflect the underlying harmony in all creation, just as the harmony of number was not man's invention, but rather an intrinsic part of creation. Those who recognize such harmonies are enriched with a sense of the beauty of the Creator.

It is not surprising to find that the number of vibrations per second in the musical scale are identical to the numbers

in the sacred Gematria of the Bible. They are God's numbers. He planted them there, and they are all in harmony.

Below is a chart of the vibrations per second, beginning with C below Middle C and progressing upward seven octaves. The numbers are on what is considered the "Just" tuning.

C	Interval	D	Interval	E	Interval	F	Interval	G	Interval	A	Interval	B	Interval
1 below 132	16.5	148.5	16.5	165	11	176	22	198	22	220	27.5	247.5	16.5
Middle C 264	33	297	33	330	22	352	44	396	44	440	55	495	33
1 above 528	66	594	66	660	44	704	88	792	88	880	110	990	66
2 above 1056	132	1188	132	1320	88	1408	176	1584	176	1760	220	1980	132
3 above 2112	264	2376	264	2640	176	2816	352	3168	352	3520	440	3960	264
4 above 4224	528	4752	528	5280	352	5632	704	6336	704	7040	880	7920	528
5 above 8448	1056	9504	1056	10560	704	11264	1408	12672	1408	14080	1760	15840	1056

Each note is a sacred number, many of which are easily recognizable. This interrelationship of the numbers of music and the Gematria of the Hebrew and Greek scriptures is awesome. Both were designed by the same Designer. A study of these numbers is too vast to include here, but there are a few items that compel our special notice.

The seven-tone scale has many remarkable properties, but one in particular stands out from all the rest. It is the perfect fifth, which has come to be known as the Chord of Triumph.

Notice that all of the G tones in this seven octave chart bear numbers that resolve to 18 and then to 9: the number 18 always referring to the Beginning and the New Beginning, and 9 always representing perfection, completion, fulfillment and finality.

G tones		
198	11 x 18	1 + 9 + 8 = 18
396	22 x 18	3 + 9 + 6 = 18
792	44 x 18	7 + 9 + 2 = 18
1,584	88 x 18	1 + 5 + 8 + 4 = 18
3,168	176 x 18	3 + 1 + 6 + 8 = 18
6,336	352 x 18	6 + 3 + 3 + 6 = 18
12,672	704 x 18	1 + 2 + 6 + 7 + 2 = 18

Seeing these seven octaves as the seventh Creation Day, we find that Jesus hung on the cross at the end of the fourth octave and the beginning of the fifth octave. When He poured out His innocent blood for the sin of Adam, all creation resounded with the Chord of Triumph.

If we are counting perfect fifths, His death would have

taken place with the ending of the seventh fifth.

But when we consider the seven octaves as the entire seven Creation Days, it is found that twelve perfect fifths contain more vibrations per second than the seven octaves. It is a mathematical impossibility, but a musical reality. This anomaly has been pondered by mathematicians and musicians since the days of Pythagoras. Counting seven sevens and twelve full fifths should end with the same number, but in music they do not. The fifths overshoot the sevens.

The difference – 1.74632 – has come to be known as the Pythagorean Comma. The frequency increase for seven octaves is 128, but for twelve perfect fifths the frequency increase is 129.74632. It overshoots the sevens by 1.74632.

The octave is measured by doubling the original number of vibrations per second, thus seven octaves would produce:

$$1 \times 132 = 132$$
$$2 \times 132 = 264$$
$$4 \times 132 = 528$$
$$8 \times 132 = 1,056$$
$$16 \times 132 = 2,112$$
$$32 \times 132 = 4,224$$
$$64 \times 132 = 8,448$$
$$\underline{128} \times 132 = 16,896$$

The perfect fifth is measured by multiples of 1.5, thus twelve fifths would produce:

$$1.5 \times 1 = 1.5$$
$$1.5 \times 1.5 = 2.25$$
$$1.5 \times 2.25 = 3.375$$
$$1.5 \times 3.75 = 5.0625$$
$$1.5 \times 5.0625 = 7.59375$$
$$1.5 \times 7.59375 = 11.390625$$
$$1.5 \times 11.390625 = 17.085937$$
$$1.5 \times 17.085937 = 25.628905$$
$$1.5 \times 25.628905 = 38.443357$$
$$1.5 \times 38.443357 = 57.665035$$
$$1.5 \times 57.665035 = 86.497552$$
$$1.5 \times 86.497552 = \underline{129.74632}$$

The difference between the vibrations per second in seven octaves and twelve perfect fifths is 1.74632. This is known as the Pythagorean Comma.

At the end of seven octaves we have the final note of conclusion – that satisfying note which all nature craves. It is the end of Earth's Great Millennium, and the note of conclusion brings us to the Great 8th Day of conclusion.

When counting by perfect fifths, it is the ending of the twelfth fifth, that overshoots the mark, and ushers in the fully operating divine government. The twelves overshoot the sevens, opening the door to eternity. It breaks the cycle of

sevens, bringing them to an end, leaving only the twelves.

Herbert Whone in *The Hidden Face of Music* describes the strange phenomenon of the Pythagorean Comma, and concludes with this revealing statement:

> We can ascertain that the frequency of the upper C is 128 times that of the lower one. But if we take the ratio of the perfect fifth we find that our twelve steps, increased by a factor of 1.5, bring us to the figure 129.75. The difference is of course known as the comma of Pythagoras. It is a strange phenomenon and a mathematical imponderable in which the octave closes the lock of predictable order and in which the fifth, overshooting the mark, opens the door to an infinity of frequencies.[1]

On God's music scale, the Pythagorean Comma opens the door to eternity.

David Tame in *The Secret Power of Music* reasoned on the universal implications of the Pythagorean Comma and concluded thus:

> Pythagoras' comma, then, can be seen as God's own engram written into the very law of the universe and of physics. And it is by the nature of this engram that man is heir to the promise of eventual resurrection.[2]

1 Herbert Whone, *The Hidden Face of Music*, Gollancz, London, 1974 p 57.

2 David Tame, *The Secret Power of Music*, Turnstone, Wellingborough, 1984, p. 250.

Creation and the Pythagorean Comma

The 12 perfect fifths, in reality, "overshoots the mark" and opens the door to eternity.

Twelve perfect fifths: frequency increase 129.74632
Seven octaves: frequency increase 128

Pythagorean Comma 1.74632

In case someone may think I'm guessing, and drawing analogies that do not exist in the Word of God, let me suggest that the reality of the Pythagorean Comma – 1.746 – is beautifully proclaimed in the Gematria of the scriptures. It was not until after studying the Pythagorean Comma, and drawing the diagram of the seven octaves on the previous page, that I looked in my Gematria notebooks that I have been compiling for the past thirty years and was stunned by finding the number 1746. My heart leaped for joy. The meaning of 1746 is precisely what the Pythagorean Comma suggests – it is the completed, fully established New Jerusalem that comes down out of heaven and engulfs the whole earth. It is the time that overshoots the mark of the end of the seven octaves, and opens the door to eternity. Look at the Gematria!

1746 = Jerusalem, the City of God,
Ιερουσαλημ η πολις Θεου
1746 = Glory of the God of Israel,
η δοξα του Θεου Ισραηλ

1 + 7 + 4 + 6 = 18

The conclusion of the seven octaves of Creation sees an increase of 128 in the vibrations per second. Remember the word *rachaph*, רחף, meaning "to vibrate" – it has a number value of 128. It began the work of creation when *"The spirit*

of God vibrated on the face of the waters." At the end of seven octaves the vibrations have increased by 128, and that scale comes to an end. There are no more sevens. Divine government, represented by 12, will have been fully established in the earth. From this point the vibrations are 129.746. The 1.746 overshoot is the number for Jerusalem, the City of God, 1746.

The Glory of the God of Israel, 1746, was that *shekinah* light which streamed from between the cherubim on the ark of the covenant in the Most Holy of the temple. The Most Holy was a cube, just like the New Jerusalem. The first was a microcosm of the second. The Pythagorean Comma, 1.746, opens the gates to eternity. This number, 1.746, was not invented by man; it occurs naturally when counting seven octaves and twelve fifths. I believe it was placed there by the Creator to herald the Great 8th Day and the opening of eternity.

In ancient times the seven tone scale was thought of as descending, rather than ascending, as we use it today. The notes were played "down" the scale because they were thought of as descending from heaven. Because of this, the names for the tones were devised to portray this divine origin. We know these notes in their descending order as DO-SI-LA-SOL-FA-MI-RE-DO. They were given these names by Guido d'Arezzo around A.D. 1000. These popular names are really only the first letters of their Latin names,

whose meaning reveals their cosmological structure.

DOminus "Lord"	**Absolute (the Beginner)**	
SIder "Stars"	**All Galaxies**	
LActea "Milk"	**Earth's Galaxy, the Milky Way**	
SOL "Sun"	**Sun**	
FAta "Fate"	**The Planets**	
MIcrocosmos .. "Small Universe" .	**The Earth**	
REgina Coeli ... "Queen of the Heavens"	**Moon**	
DOminus "Lord"	**Absolute (the New Beginner)**	

It becomes apparent that the scale was meant to model the macrocosm design – the universe ruled by the octave. It originates from above, and starts with the Absolute, the Creator, the Beginner, and descends through a seven-stage hierarchy, and returns again to its tonic, the Absolute. This time it is the New Beginner, but the same musical tone.

The 7,000 years of man's experience, leading to and culminating in the Great 8th Day can be likened to a string stretched between two points. Pluck the string and the tone we hear represents the Beginning and the New Beginning – both ends of the octave. Pluck it at two-thirds of its length and it sounds the perfect fifth, representing the time when salvation was made possible by the death of Jesus. Pluck the

two together and we hear the resounding harmony of the Chord of Triumph – the great resounding harmony of God's work of salvation, restitution and reconciliation complete.

On the Day of Atonement the trumpet of Jubilee (*yobel*) was blown. It was a ram's horn (*shofar*) with a special metal sound bell to amplify the sound. Those who have heard its magnificent blast can never forget the sound. It is the fundamental and the fifth in a resounding Chord of Triumph.

The trumpet of Jubilee, the *yobel,* was blown at the completion of 49 years to herald the 50th year, the year of returning, the Jubilee Year. On the seven scales of the Music of the Ages, the completion of 49 notes brings us to the completion of the 7,000 years of the seventh epoch of creation. The blowing of the Jubilee trumpet heralds God's Grand Jubilee, finishing the count of seven and beginning the Great 8th Day.

The final 49th note is the Tabernacles Age. It is the age of the "drawing of water" – the water of life. It is the age of "illumination" – the shedding abroad of the light of the knowledge of God. It is the age of rejoicing and of dancing and of sharing of food; and it is the age of the healing of the nations.

> *"Arise, shine, for thy light is come, and the glory of the Lord is risen upon thee ... and the Gentiles shall come to thy light, and kings to the brightness of thy rising ... and they*

shall call thee The City of the Lord, the Zion
of the Holy One of Israel ... the sun shall be
no more thy light by day; neither for bright-
ness shall the moon give light unto thee; but
the Lord shall be unto thee an everlasting
light, and thy God thy glory." (Isaiah 60)

It brings us to the end of the seventh octave, the end of the 49th note, to the time that God promised, when He "sevened Himself" to Moses:

"As truly as I live, all the earth shall be filled
with the glory of the Lord." (Numbers 14:21)

It was a sworn oath.

The completion of 49 notes on the music scale of Creation is exactly what the number 49 denotes. The word תמים, adding to 490, means complete, full, whole, unde- filed, perfect. (Perhaps this is why Jesus said we should for- give 70 x 7 [490] times. He was telling us about *complete* forgiveness.) The word "perfection," תמים, has a number value of 490; thus that which follows the 49th note is the endless age of perfection – eternity.

At the end of the seven days of Tabernacles, they came out of their booths and celebrated one more day, the 8th day, which was called *Atzereth,* or "day of conclusion." It is the final and 8th note of the seven octaves, sounding the tonic, the note that all nature craves.

Then can be heard the great voice out of heaven saying:

> *"Behold, the tabernacle of God is with men, and he shall dwell with them, and they shall be his people. And God himself shall be with them and be their God. And God shall wipe away every tear from their eyes, and there shall be no more death, neither sorrow, nor crying, neither shall there be any more pain, for the former things have passed away ... and he said unto me, It is done. I am the Alpha and Omega, the beginning and the end. I will give unto him that is athirst of the fountain of the water of life freely."* (Revelation 21:1-6)

"It is done," γεγονεν, has a number value of 186. From that point in time, at the end of the 49th note, the promise *"And there shall be no more curse: but the throne of God and of the Lamb shall be in it,"* shall be fulfilled.

186 = It is done, *γεγονεν*

1860 = And there shall be no more curse,
και παν καταθεμα ουκ εσται ετι

The days of the three pilgrim festivals will have come to an end. The first was Passover, the second Pentecost, and the third Tabernacles. There are exactly 186 days from Passover to the end of the seven days of Tabernacles. When the end of the Tabernacles Age is complete, the 186 days are complete and it then can be said, *"It is done,"* – 186. The curse that had been placed upon Adam and the earth will be fully lifted. *"And there shall be no more curse,"* – 186.

> *"And I the Lord will be their God, and my*
> *servant David* (Jesus) *a prince among them*
> *... and the tree of the field shall yield her fruit,*
> *and the earth shall yield her increase."*
> (Ezekiel 34:24-27)

Appendix I
Aleph Tau

The Hebrew alphabet is like no other. The names of the individual letters, their graphic forms, their Gematria, and their respective positions are Divinely ordained. They are more than merely empty symbols of sound.

The alphabet (aleph-bet) is composed of 22 letters: three octaves plus its note of conclusion.

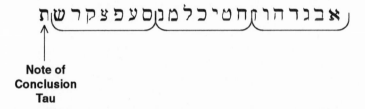

**Note of
Conclusion
Tau**

When the note of conclusion is placed at the end of the alphabet, each grouping of three will resolve to 6. The alphabet, however, is self repetitive, which means that *aleph,* א, immediately follows *tau,* ת. When the function of the alphabet is seen from this perspective, the note of conclusion can become א, causing each grouping of three to resolve to 9. The number 6 pertains to man and the earth; and because sin and imperfection entered, it takes on this flavor. The number 9 is the number of perfection, comple-

tion, fulfillment and finality. It speaks of the completed plan of God as reaching its fullness. Both concepts are inherent within the Hebrew alphabet.

	Gematria	Digit sum
אבג	1+2+3 = 6	6 = 6
דהו	4+5+6 = 15	1+5 = 6
זחט	7+8+9 = 24	2+4 = 6
יכל	10+20+30+ = 60	6+0 = 6
מנס	40+50+60 = 150	1+5+0 = 6
עפצ	70+80+90 = 240	2+4+0 = 6
קרש	100+200+300 = 600	6+0+0 = 6
בגד	2+3+4 = 9	9 = 9
הוז	5+6+7 = 18	1+8 = 9
חטי	8+9+10 = 27	2+7 = 9
כלמ	20+30+40 = 90	9+0 = 9
נסע	50+60+70+ = 180	1+8+0 = 9
פצק	80+90+100 = 270	2+7+0 = 9
רשת	200+300+400 = 900	9+0+0 = 9

Psalm 119, which is a beautiful acrostic on the Hebrew alphabet, declares, *"Thy word is true from the beginning."* The English translation looses the beauty of the meaning. Literally it should read, *"The sum of your word is truth forever."* The word "truth" is an acronym for the Hebrew phrase, אלהים מלד תמיד, which in English is, *"God is the eternal King, in the infinite past, present and future."* Taking the first letter of each Hebrew word, forming an acronym, they arrived at אמת, *emet*, as the word for "Truth." Its Gematria

is 441. Absolute Truth, האמת הגמור, has a numeric value of 700.

The word *emet* – Truth – is also the full embrace of the Hebrew alphabet. It is the first, middle and last letter, when including the finals. (Read from right to left.)

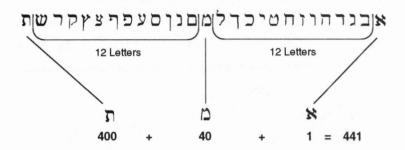

Thus Truth brings us all the way from the beginning, to the final transformation of sevens into twelves.

It is probably for this reason that the Torah begins with ב, which causes the groupings of threes to resolve to nines. God planned the end from the beginning, and the way of redemption was set in place long before man needed redemption.

Since the power of Truth lies in its results, the acronym אמת is symbolized by its final letter, ת. Thus ת means Truth.

The letter ת was, in ancient Hebrew, written as a cross. It was a symbol of the One who was the very personification of Truth, and the ultimate sacrifice that He would make to redeem Adam and all of Adam's family.

In Ezekiel's vision (chapter 9) he heard instructions from God to *"Go through the midst of the city ... and set a mark upon the foreheads of the men that sigh and that cry for all the abominations that be done in the midst thereof."* The "mark" was a ת, and so it is written in the Masoretic Text; although in Ezekiel's day it probably was written as a cross.

The Greeks and the Romans took this from Hebrew and incorporated it into their alphabets as the letter T – the sign of the cross. The position it holds in the Greek alphabet gives it the Gematria number 300, implying the resurrection.

When Pilate asked Jesus *"What is truth,"* Jesus' reply indicated that He was the very personification of Truth. Jesus used the word *aletheia, αληθειας,* which has a numeric value of 264. The number 264, when multiplied by 3, representing resurrection, produces 792, which is "salvation."

The Rabbi Maharal, in the sixteenth century, compared אמת, Truth, to the life-sustaining sun, which illuminates the world and can never deviate from its precisely defined orbit – so Truth is precisely bound, and can never change. By definition, Truth is eternal; it can never be nullified, voided or distorted. It always exists.

Just as the cycle of the alphabet repeats itself, so ת automatically brings us back to א. The two are inseparable. Truth and Unity (Beginning) are so intertwined that they are bound together eternally.

This is the implication and the impact of the use of the

untranslatable אֵת which is used profusely throughout the Old Testament. It is used as an object marker, to call attention to the object – to give it its recognition of importance. We see its fuller meaning in the book of Revelation, when God takes the אֵת to Himself and proclaims:

> *"I am the Alpha and the Omega, the beginning and the end. I will give unto him that is athirst of the fountain of the water of life freely. He that overcometh shall inherit all things* (panta, παντα, 432) *and I will be his God, and he shall be my son."* (Revelation 21:6-7)

Where are we in time?

An Exciting Book
for the
New Millennium,
Confirming our place in
God's Time-Line for Man.

Time and the Bible's Number Code

by Bonnie Gaunt

The Patterns of the Number Code (Gematria) and the patterns of time, combine with the patterns of the Golden Proportion to tell God's magnificent story, and confirm our place, today, in His plan for man.

Additional evidence from the Bible's Number Code, Stonehenge, and the Great Pyramid

The Stones and the Scarlet Thread

by Bonnie Gaunt

The Bible's Number Code reveals an amazing end-time confirmation of our faith in the redemptive power of the blood of Jesus Christ. The story of the Scarlet Thread is woven through the pages of time. This remarkable story has been revealed to us through the Word written, the Word in number, the Word in the cosmos, and the Word in stone. Evidence found in the measurement and construction of Stonehenge and the Great Pyramid confirm the beautiful story of the Scarlet Thread.

Order from Adventures Unlimited Press

More about the
Number Code of the Bible!

The Bible's Awesome Number Code
by Bonnie Gaunt

Using the Number Code, it is found that the parable of the Good Samaritan is, in fact, a time prophecy, telling the time of Jesus' return. His miracles of healing and of turning water into wine have been encoded with evidence of the time and the work of the beginning of earth's great Millennium. The Number Code takes us on a journey from Bethlehem to Golgotha, and into the Kingdom of Jesus Christ.

Jesus Christ
and the
Amazing Number Code
Found in the Bible!

Jesus Christ
the Number of His Name

by Bonnie Gaunt

The Bible's number code tells of the new Millennium and the Grand Octave of Time for man. It reveals the amazing relationship of the number code to the ELS code in the prophecies of the coming of Jesus. Explores the relationship of the Golden Proportion to the name and work of Jesus.

Order from Adventures Unlimited Press

Additional Books About the Gematria Number Code of the Bible.

The Coming of Jesus
the Real Message
of the Bible Codes!
by Bonnie Gaunt

The constellations of the heavens are a picture code, telling the same story of the end-time as is found in the number code and the ELS code of the Bible.

Beginnings
the Sacred Design
by Bonnie Gaunt

The Bible's Number Code reveals an amazing design woven into all creation – a design of which we are a part. From the atom to the solar system this design tells of a magnificent Creator who planned for eternity. The relationship of music to the Gematria of the Bible is shown in its simplicity. This book explores the "what," "when" and "how" of the origins of man, our earth, our solar system, and our universe.

Order from Adventures Unlimited Press

Books by Bonnie Gaunt

TIME AND THE BIBLE'S NUMBER CODE
$14.95

THE STONES AND THE SCARLET THREAD
$14.95

THE BIBLE'S AWESOME NUMBER CODE
$14.95

THE COMING OF JESUS
The Real Message of the Bible Codes!
$14.95

JESUS CHRIST
The Number of His Name
$14.95

BEGINNINGS
The Sacred Design
$14.95

STONEHENGE AND THE GREAT PYRAMID
Window on the Universe
$14.95

THE MAGNIFICENT NUMBERS
of the Great Pyramid and Stonehenge
$9.95

Order From:
Adventures Unlimited Press, P.O. Box 74, Kempton, IL 60946, U.S.A.
Tel. 815-253-6390 FAX 815-253-6300
email: auphg@frontiernet.net
www.adventuresunlimitedpress.com

One Adventure Place
P.O. Box 74
Kempton, Illinois 60946
United States of America
Tel.: 815-253-6390 • Fax: 815-253-6300
Email: auphq@frontiernet.net
http://www.adventuresunlimitedpress.com
or www.adventuresunlimited.nl

ORDERING INSTRUCTIONS

✓ Remit by USD$ Check, Money Order or Credit Card

✓ Visa, Master Card, Discover & AmEx Accepted

✓ Prices May Change Without Notice

✓ 10% Discount for 3 or more Items

SHIPPING CHARGES

United States

✓ Postal Book Rate { $3.00 First Item / 50¢ Each Additional Item

✓ Priority Mail { $4.00 First Item / $2.00 Each Additional Item

✓ UPS { $5.00 First Item / $1.50 Each Additional Item

NOTE: UPS Delivery Available to Mainland USA Only

Canada

✓ Postal Book Rate { $6.00 First Item / $2.00 Each Additional Item

✓ Postal Air Mail { $8.00 First Item / $2.50 Each Additional Item

✓ Personal Checks or Bank Drafts MUST BE
USD$ and Drawn on a US Bank

✓ Canadian Postal Money Orders OK

✓ Payment MUST BE USD$

All Other Countries

✓ Surface Delivery { $10.00 First Item / $4.00 Each Additional Item

✓ Postal Air Mail { $14.00 First Item / $5.00 Each Additional Item

✓ Payment MUST BE USD$

✓ Checks and Money Orders MUST BE USD$
and Drawn on a US Bank or branch.

✓ Add $5.00 for Air Mail Subscription to
Future *Adventures Unlimited* Catalogs

SPECIAL NOTES

✓ RETAILERS: Standard Discounts Available

✓ BACKORDERS: We Backorder all Out-of-
Stock Items Unless Otherwise Requested

✓ PRO FORMA INVOICES: Available on Request

✓ VIDEOS: NTSC Mode Only. Replacement only.

✓ For PAL mode videos contact our other offices:

Please check: ☑

☐ This is my first order ☐ I have ordered before

Name				
Address				
City				
State/Province			Postal Code	
Country				
Phone day		Evening		
Fax				

Item Code	Item Description	Qty	Total

Please check: ☑

Subtotal ➡ _____

Less Discount-10% for 3 or more items ➡ _____

☐ Postal-Surface

Balance ➡ _____

☐ Postal-Air Mail (Priority in USA) Illinois Residents 6.25% Sales Tax ➡ _____

Previous Credit ➡ _____

☐ UPS

Shipping ➡ _____

(Mainland USA only)Total (check/MO in USD$ only) ➡ _____

☐ Visa/MasterCard/Discover/Amex

Card Number _____

Expiration Date _____

10% Discount When You Order 3 or More Items!